TRADITIONAL SANTA CARVING WITH TOM WOLFE

Text written with Douglas Congdon-Martin

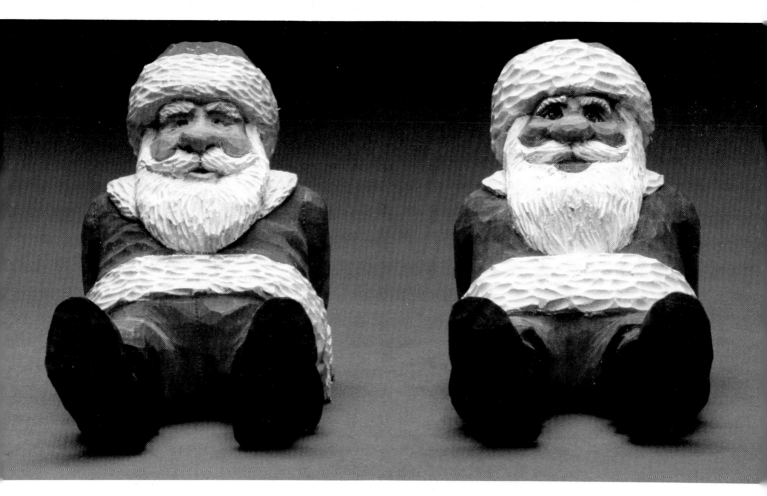

Schiffer Publishing Ltd

77 Lower Valley Road, Atglen, PA 19310

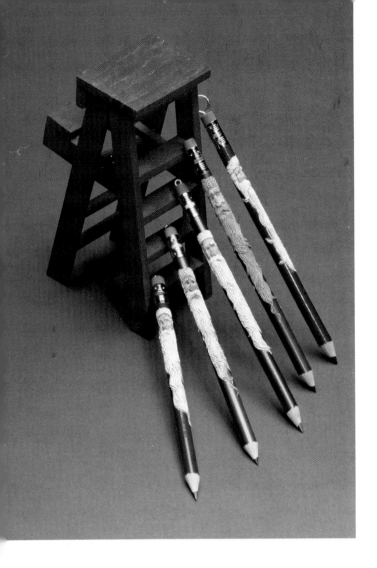

Contents

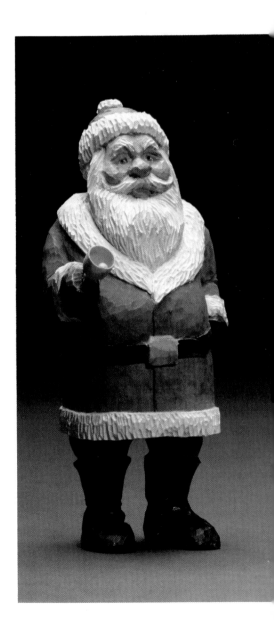

Published by Schiffer Publishing, Ltd.
77 Lower Valley Road
Atglen, PA 19310
Please write for a free catalog.
This book may be purchased from the publisher.
Please include $2.95 postage.
Try your bookstore first.

We are interested in hearing from authors
with book ideas on related subjects.

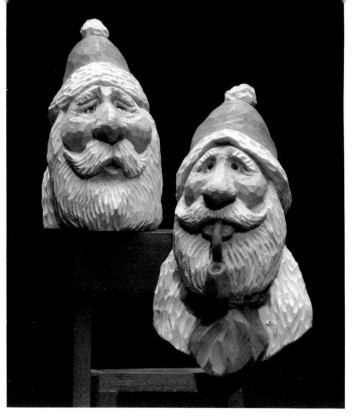

Introduction

I suppose the title of this book is not quite accurate. The traditional Santa is really more like the ones in my first Santa carving book *Santa and His Friends*. In their flowing hooded robes they were the Santas of the old world, Saint Nicholas or Father Christmas.

The Santas in this book are all-American Santas. They have their root in Thomas Nast's drawings of Santa in *Harper's Illustrated Weekly* in 1866. This is the Santa of "'Twas the Night Before Christmas." In the trade these are known as "Coca-Cola" Santas, because their use in the advertising for that soft drink has established this as the way Santa ought to look.

I tried to think of a joke about Santa, but there just aren't too many. People don't tell many jokes about folk heroes, real or imaginary. The best stories about Santa come from real life. When my wife, Nancy, was young, when it was just she and her baby brother in the family, she got it in her mind to stay up all night and see Santa. Her daddy warned her that if Santa saw her she wouldn't get anything, but it didn't make any difference to her.

She sat by the window looking out for the telltale sleigh and reindeer. Every now and then she would see something or hear something and run to the tree, hoping to spy Santa. This happened several times, but there was no sign of Santa. Then she heard a sound she was sure must have come from him. She ran to the tree and found it surrounded with wonderful gifts. Her father was there too, and when she went to the beautiful Teddy bear he stopped her. "That's not for you. It's your brother's. I told you Santa wouldn't come."

She went to a sled in the corner, and a train, and a nicely wrapped gift box that would surely hold a doll. But every gift, every one, was for her brother. Not one of the toys, not one of the gaily wrapped packages, was for her.

Seeing that she was on the verge of tears her daddy put his arm around her and said, "Santa told me he was going down the street. When he is finished there he will come back here. If you are not asleep, you don't get anything. But if you are asleep..."

Before he could finish his sentence Nancy was in her bed with the covers pulled over her head. In a matter of seconds she was fast asleep.

I have lots of uncles, and the thing they have in common is that they are all comical. Probably the funniest is Uncle Carl, who we lovingly call Chicken.

One time he found himself deep in a discussion about how it was way back when nobody had any money. Someone said, "We were so poor when I was a kid I could look up and see the stars through the cracks in the ceiling."

"That ain't nothin'," said Uncle Chicken. "We was so poor you could fall through the cracks in the floor."

One year at Christmas we were talking about what he got from Santa when he was young.

"Did your dad make you something?" I asked.

"Naw, he couldn't afford to make something for everyone, not with 6 boys and 6 girls in the family. But one year he did make us a big red sled to share. It was big enough to hold two or three of us."

"Did it go fast?"

"Don't know. The only thing they would let me do is pull it back up the hill."

The nice thing about this book is that I'll let you do it all. The projects require only a few simple tools, and are perfect for the advanced beginner and intermediate carver. They should also be challenging for the advanced carver.

I have carved a reclining Santa, so you can see how it is done step-by-step. The other Santas are carved in a similar way. Good luck and good fun!

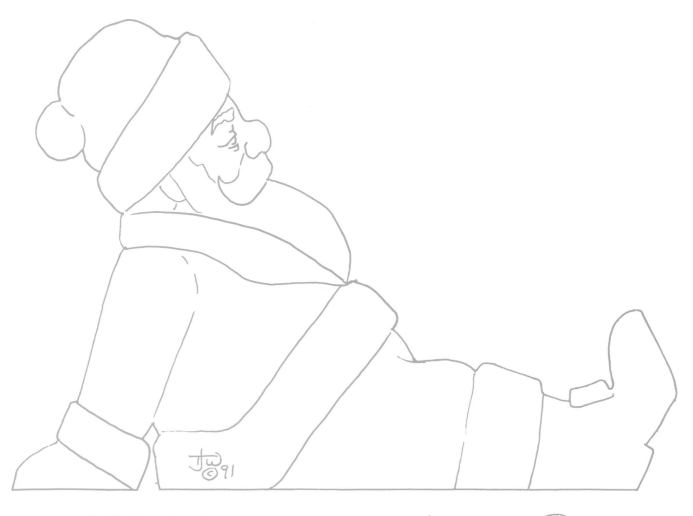

The Tools and Patterns

The tools needed for this project include a simple set of palm gouges, a turned-down blade and a turned-up blade, and some eye punches or nail sets for the eyes and buttons. The wood I use is bass, and it is probably the best for these figures. It carves well and takes the paint nicely.

The patterns may be used as they appear or you may enlarge or reduce them on a photocopying machine. While you are at the machine, print several copies so you can cut them apart as needed to help in drawing various parts.

The Patterns

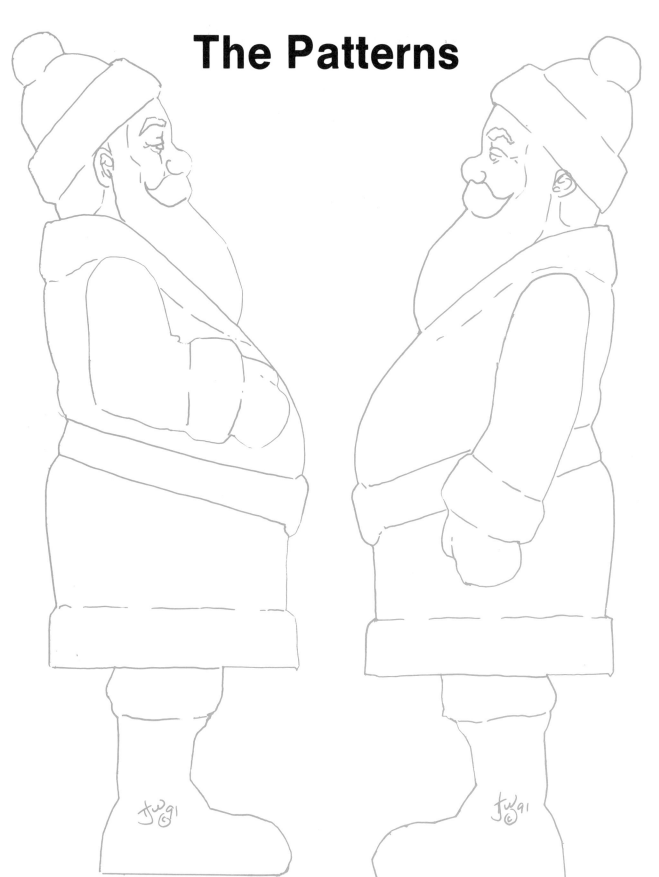

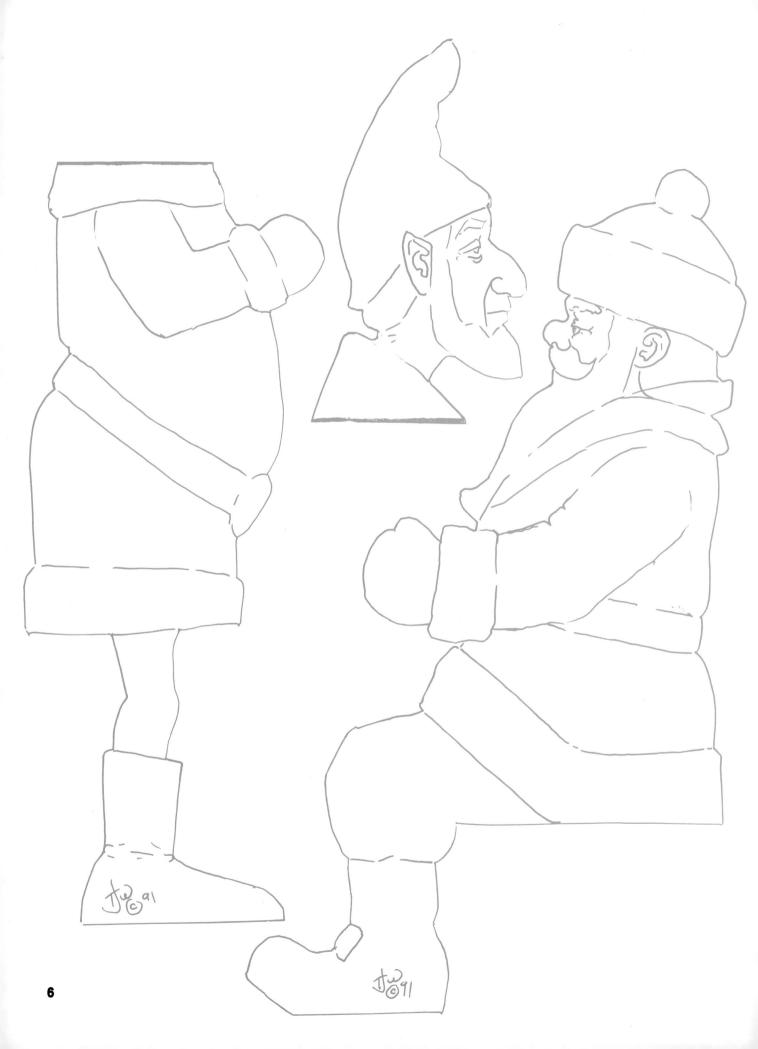

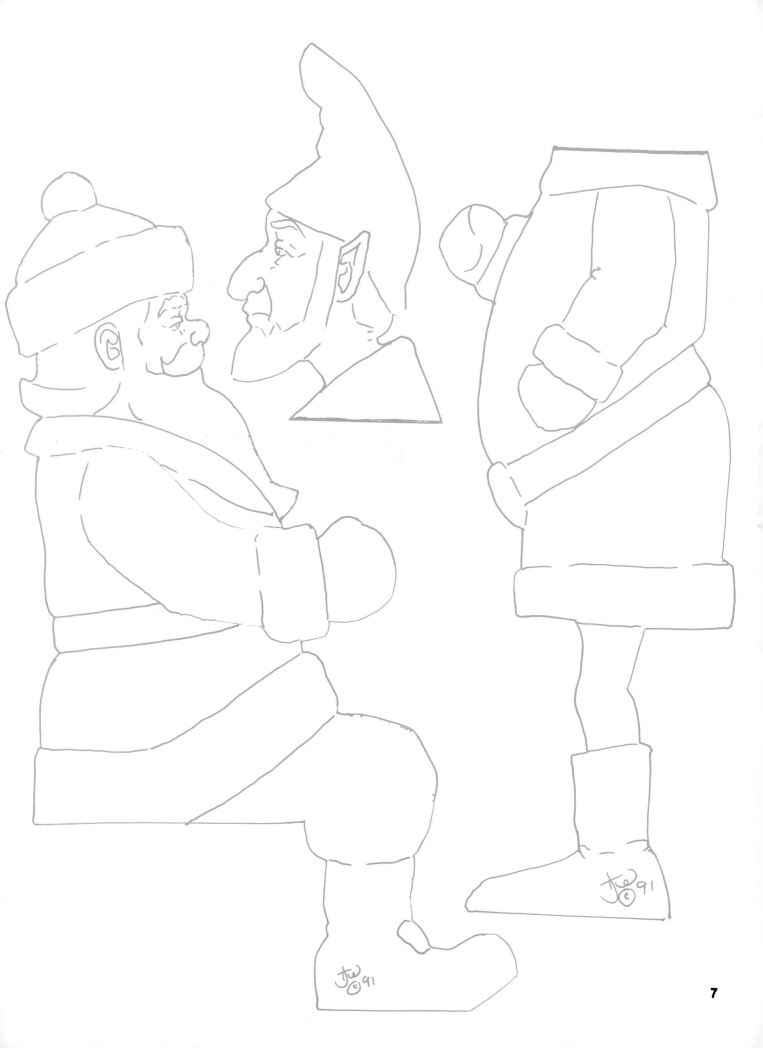

Carving the Traditional Santa

Begin by cutting out the blank on a bandsaw.

Find the center...

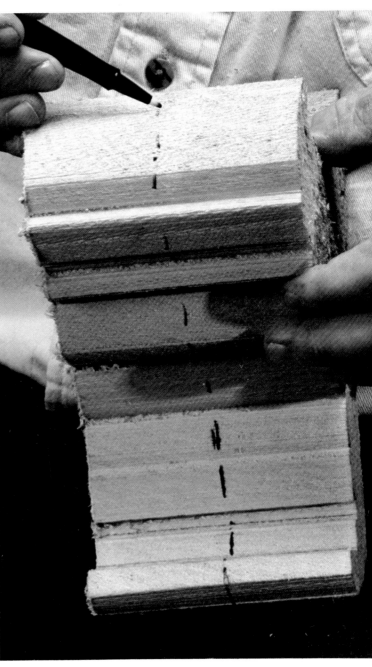

and mark it up the front and around the back.

8

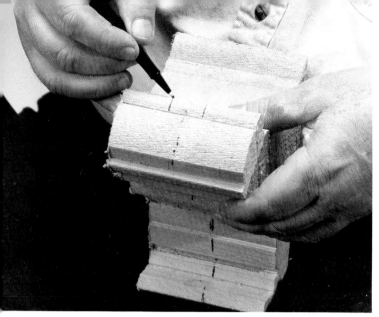

Mark the ball on the back of the hat.

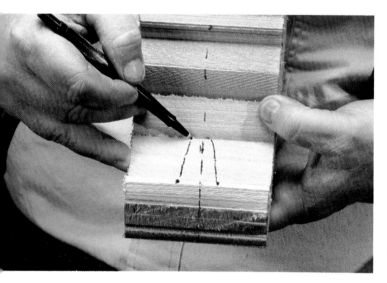

Mark the inside edges of the feet and legs up to the crotch. Be sure to leave the feet plenty wide for now, so you can turn the feet for effect.

Mark the width of the head, again leaving plenty of width for your carving needs.

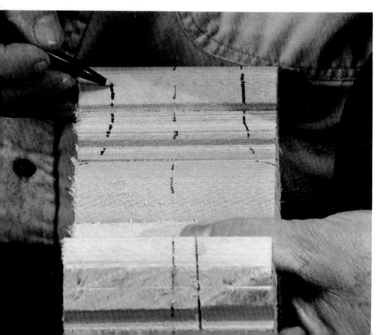

Remove the space between the legs and the excess beside the head with a coping saw or a bandsaw.

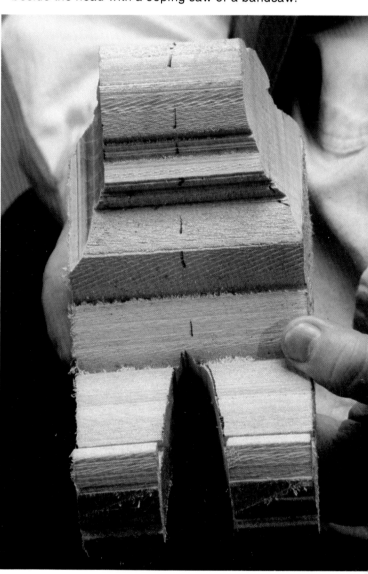

This saves quite a lot of carving, an lets you conserve your energy for the more creative steps

9

At the back of the head, trim from both sides to leave the ball on Santa's cap.

and the space between the arms in the back.

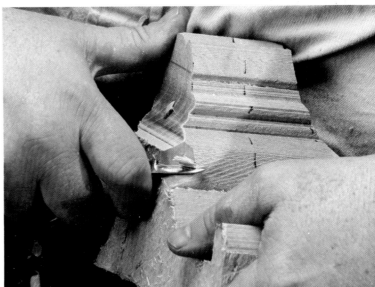

Continue to round off the ball.

Knock off the corners of the upper body...

giving this appearance.

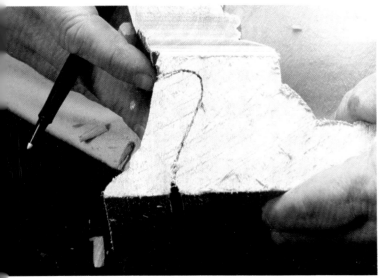

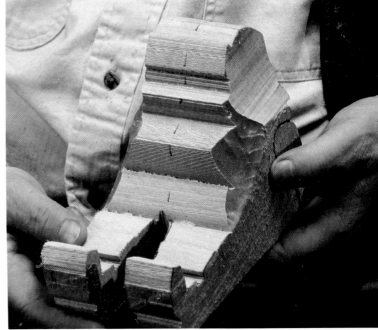

Mark the arms and shoulders...

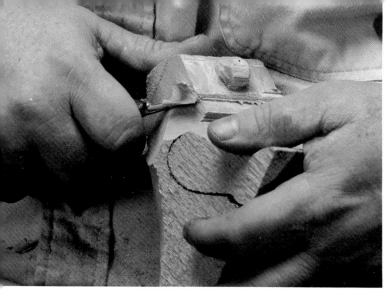

Then knock off the back corner of the neck/shoulder.

On the corners of the fur trim, cut a stop in the bottom line...

Continue the shoulder up to the neck.

Draw in the fur trim at the bottom of the hat.

and cut back to it.

When the corners are done come back and continue to form the bottom line of the fur trim around the hat. Cut a stop...

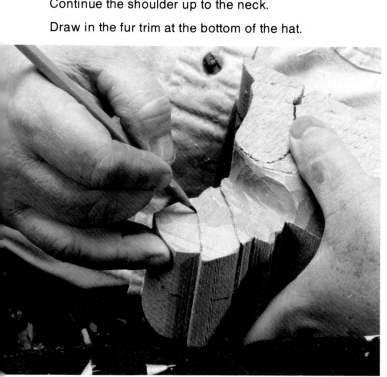

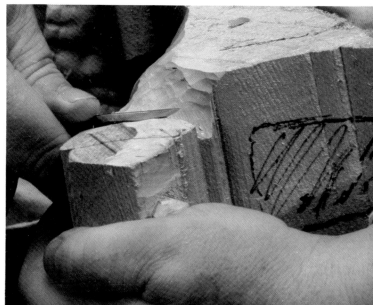

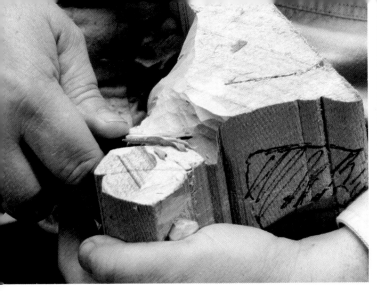

and cut back to it. Continue the process all around the hat until you get as deep as you want.

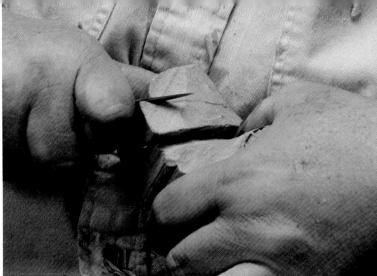

Do the same thing on the top line of the fur trim. Cut a stop at the corner...

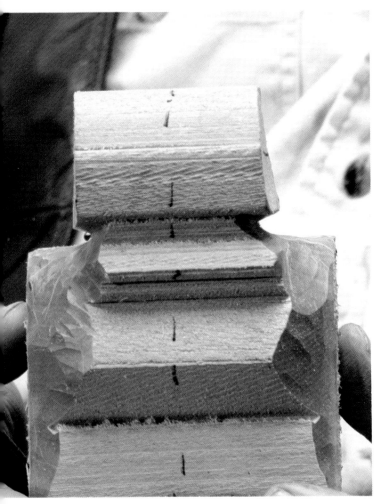

It should look something like this when you are finished with this step.

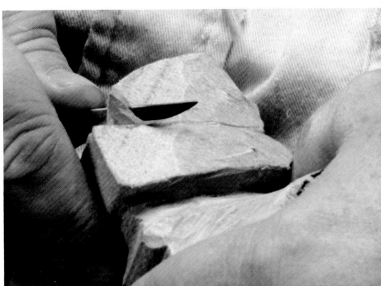

and cut back to it. Do this on all four corners.

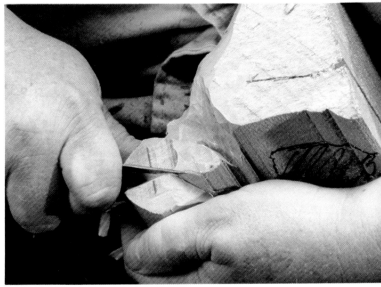

Next cut a stop along the line between the corners...

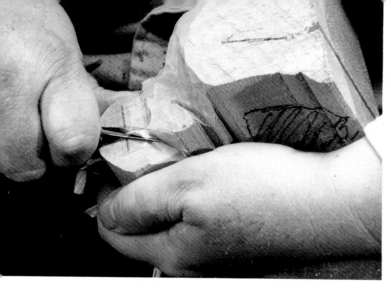

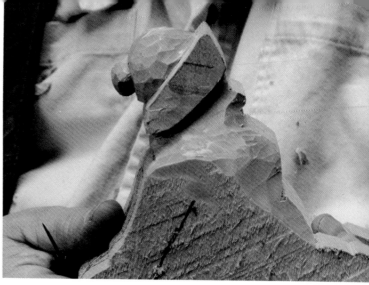

and cut back to it. Again, do this all around the top of the fur trim.

This profile shows the flatter top and the little fold at the back that gives the floppy look.

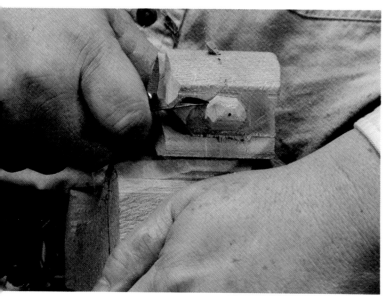

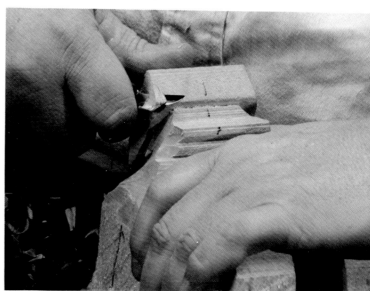

Round off the top of the cap. You want it to look floppy, not tight.

Begin rounding off the fur trim by popping off the corners.

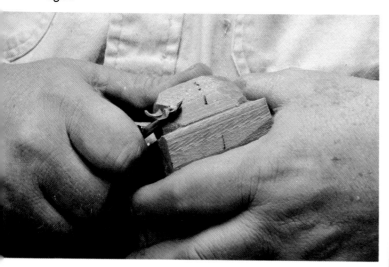

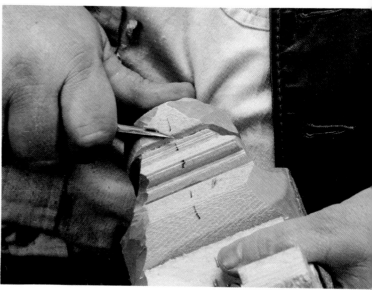

Trim away from the front to give it that flopped-back look. Notice the thumb position. It is a good idea to keep your thumbs hidden to avoid injury.

Then round the area between the corners.

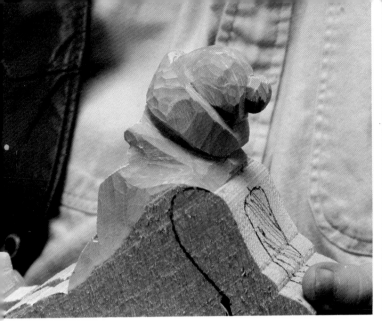

The hat thus far.

Use a flat gouge to cut stops beside the nose, with the cupped side of the gouge turned toward the nose.

With the same gouge cut into the stop from the side of the head.

It is now time to begin shaping the face. Mark the place for the nose, leaving it wide for now.

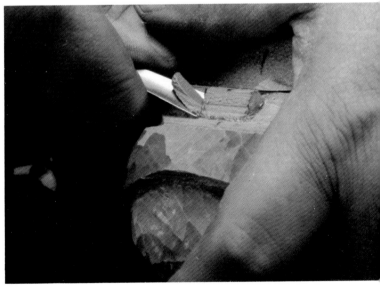

Keep taking away wood until the cheek area is flat.

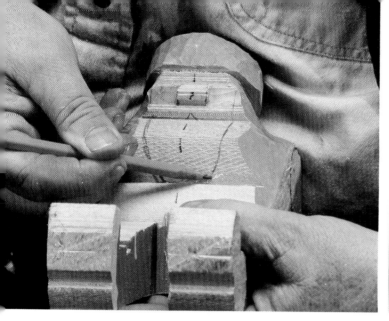 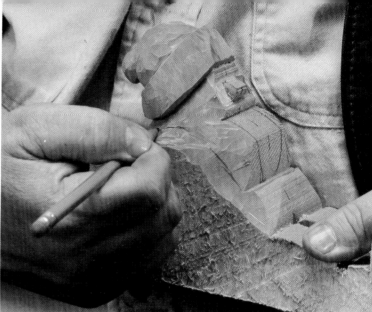

Next we come across the chest to the place where the beard will lay. Mark in the beard. in the front... and the side.

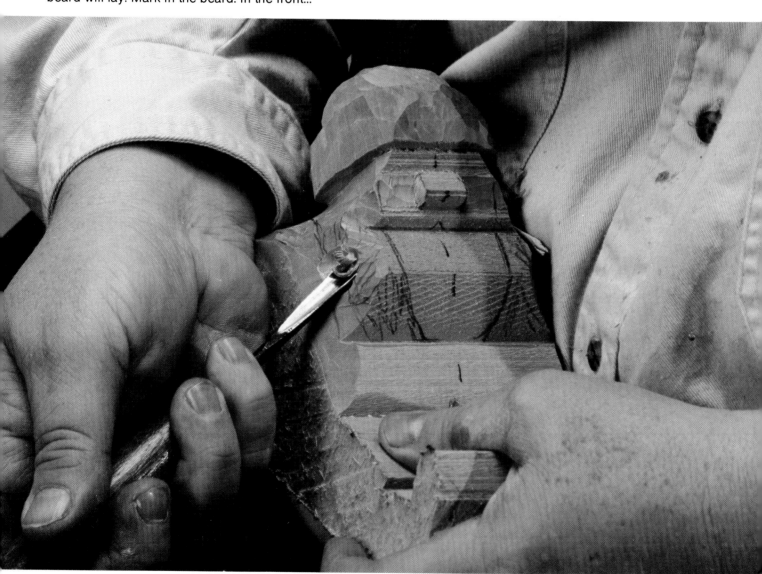

Blacken the space to be removed, and use a gouge to take it away.

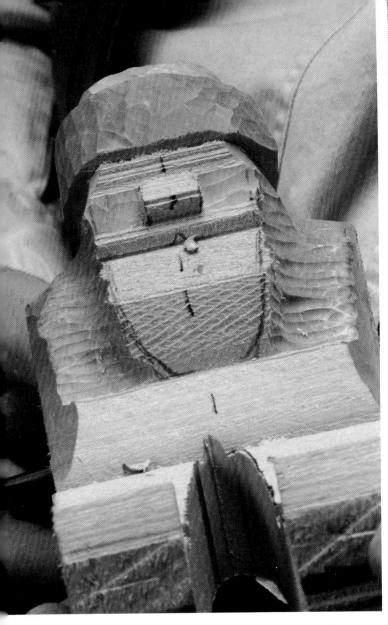

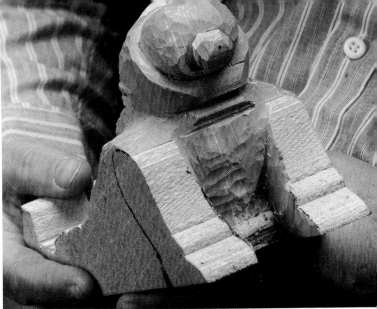

The roughed out back.

The upward cutting motion of the gouge creates this sloping effect.

Cut a stop up the inside of the arms.

Use a knife to open the gap between the arms in the back of Santa.

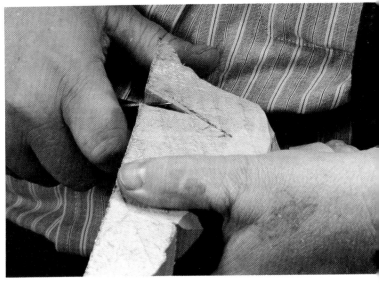

Cut back to it from the body.

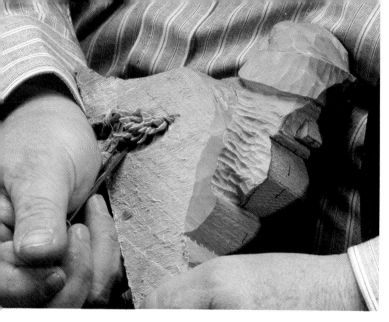

Round the body toward the arm. A gouge in this spot seems to work pretty well.

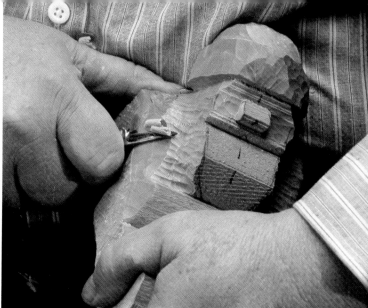

Round off some the surfaces, beginning with the upper body.

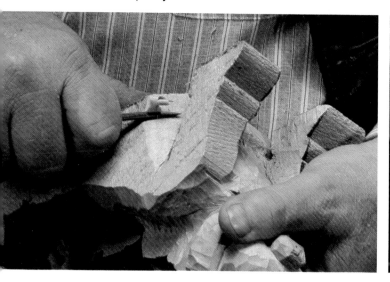

Smooth out the gouge marks with the knife and repeat the process on the other side.

I'm going to take a moment to knock off some edges. They will come off anyway, but doing it now will make the piece easier to hold, reduce the fatigue factor, and make the carving more enjoyable.

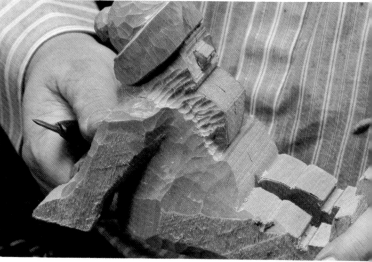

This will bring the arm out. Continue on the other side.

The carving is tough here so I've switched to a longer blade with more cutting surface and a bigger handle. This works better in this particular situation where I'm trying to remove a lot of wood, **but it also increases the danger of being cut**.

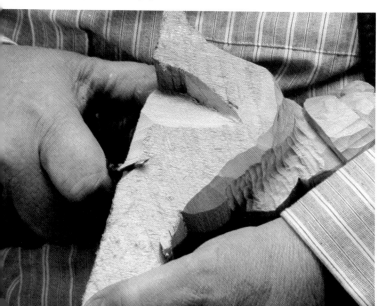

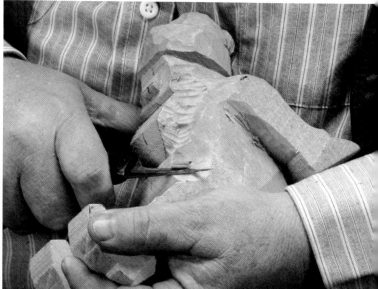

I've started to round out the leg, but notice the scratch my knife is leaving in the wood. This is a sure sign that I need to hone the blade on the stone. Somewhere along the way it has picked up a nick.

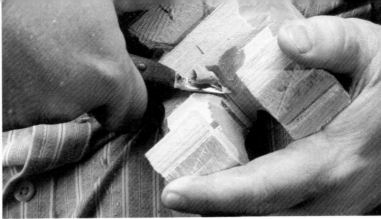

Round off the inside of the leg, into the crotch.

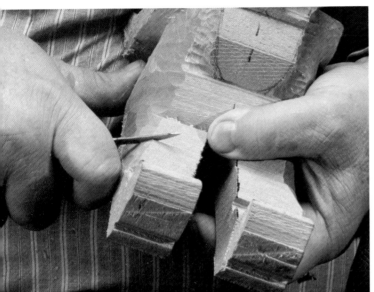

After sharpening the knife I return to the legs, rounding off the top down to the top of the boots where I cut a stop.

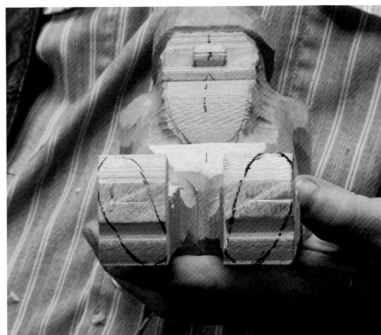

The feet should turn out a little bit as marked here.

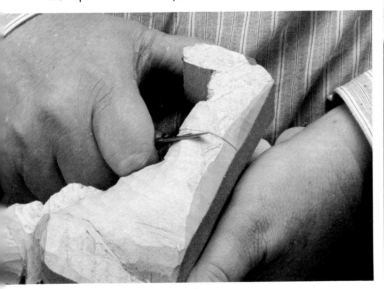

Carry the stop around the boot and cut back to it from the leg.

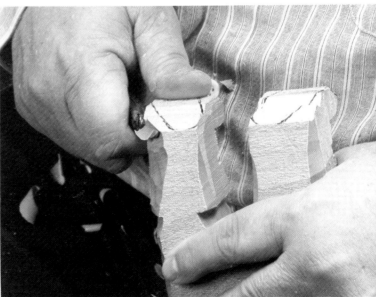

Trim the boot down...

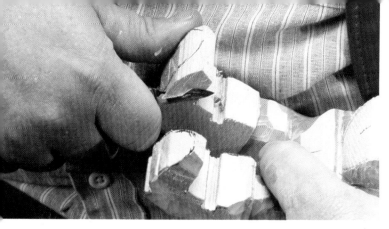

to the mark.

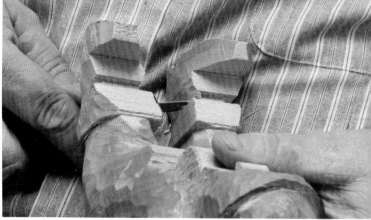

Continue all around the boot.

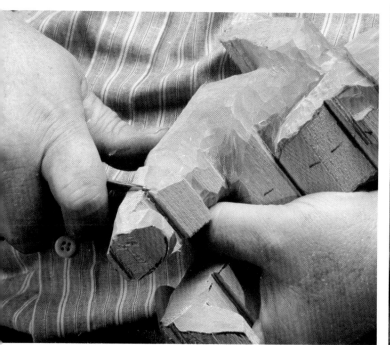

We'll go ahead and shape the boots. These boots have turned-over cuffs. Cut a stop around the bottom of these cuffs...

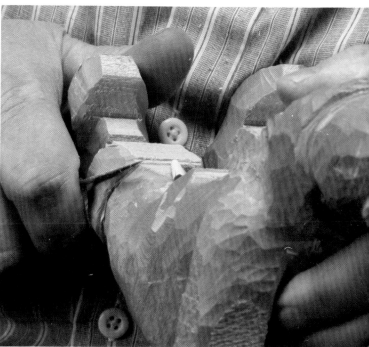

Round the toes and the cuffs of the boot.

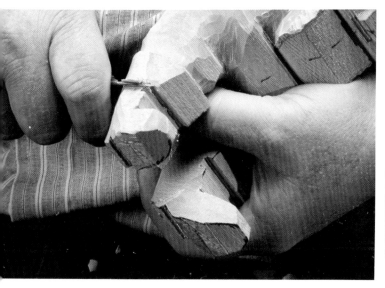

and cut back to it.

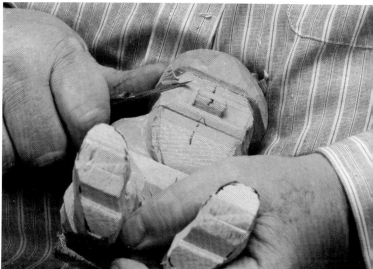

Moving to the face we begin by knocking the corners off the cheeks. The whole process of carving is first squaring, then rounding off and finishing.

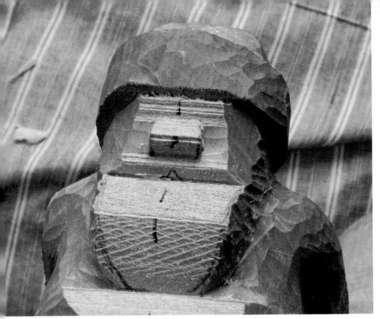

The face begins to take shape.

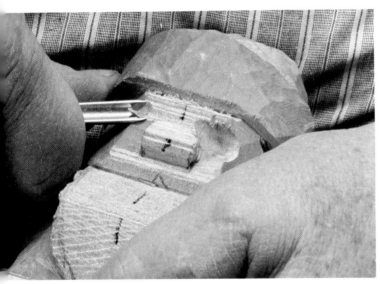

Use a gouge to form the eye sockets.

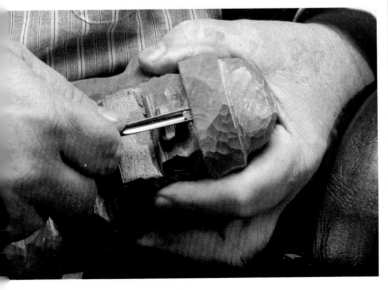

Next use a gouge to separate the eyebrows.

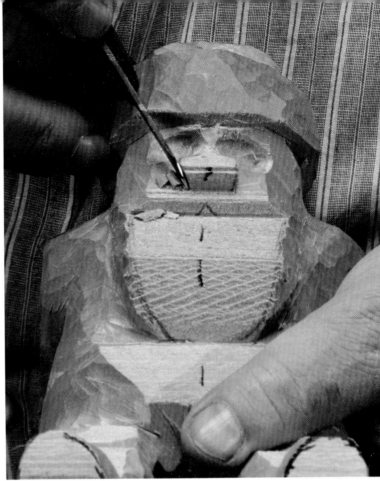

Round off both sides of the nostrils using a knife.

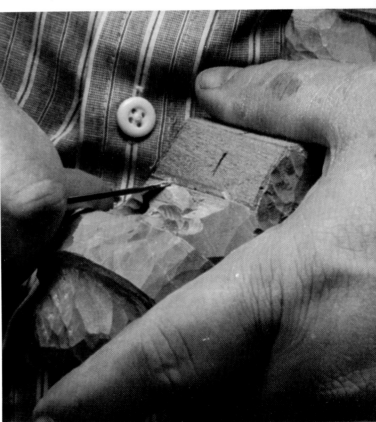

Then round off the front of the nose.

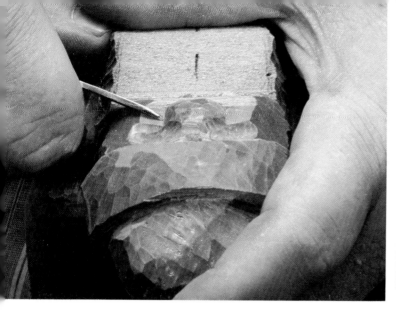

To form the cheek line cut a stop from the nostril to the corner of the moustach.

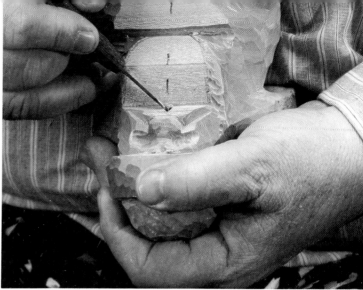

To make Santa appear as jovial as he should be, always cut a little nitch at the center of the moustach to separate the two sides.

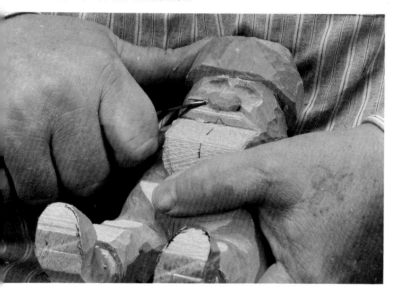

Cut back to it from the moustach.

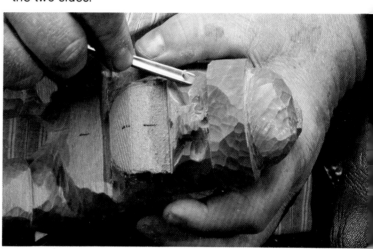

Define the line between the cheek and the sideburn using a gouge. It is important to keep this symmetrical, so cut a little bit from one side...

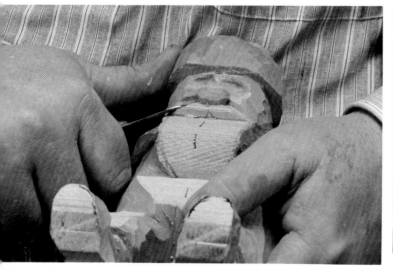

Deepen these lines to give shape to the moustach and the cheek.

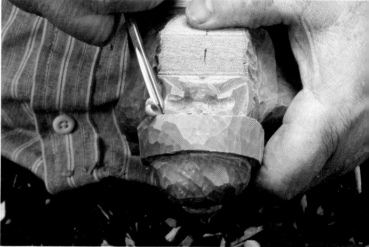

then the other. Going from one side to the other will help with the symmetry. This works for eyes and other body parts as well.

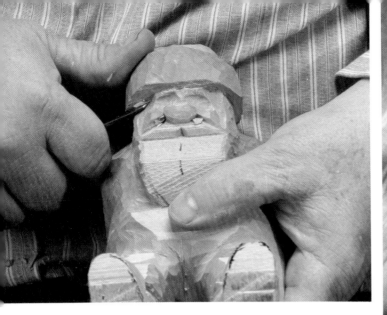

Go back over the lines with a knife to straighten them up.

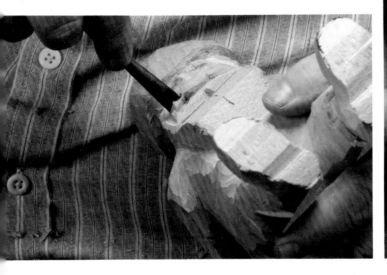

Use a flatter gouge to round the cheek into moustach. Placing the cup of the gouge over the cheek will give it the roundness we desire.

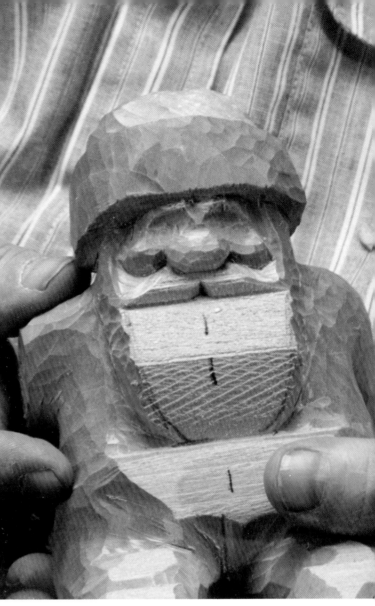

The result of this gouging is a nice round cheek and upturned moustach.

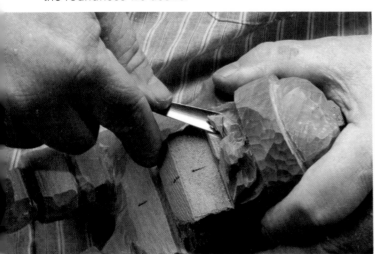

Use the same gouge to cut off the wood, with the inside of the gouge facing up this time. This will give the upturned look you want in the moustach.

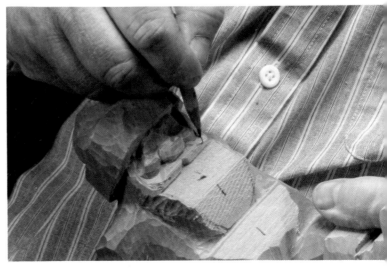

Mark the shape of the bottom edge of the moustach, giving it a nice turn at the end.

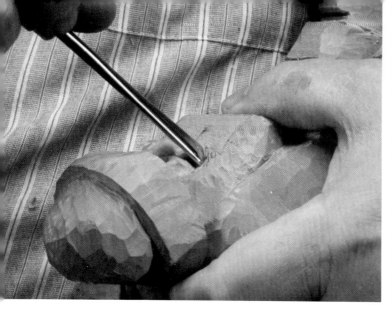

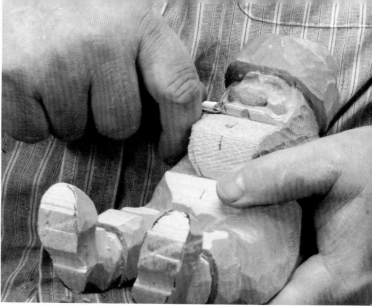

Follow the pencil line with the curve of the gouge, pressing straight in to form a stop.

Cut back to the stop with the gouge, pushing and rocking to gently remove the corner. Notice how the placement of my forefinger helps keep me from cutting too deeply.

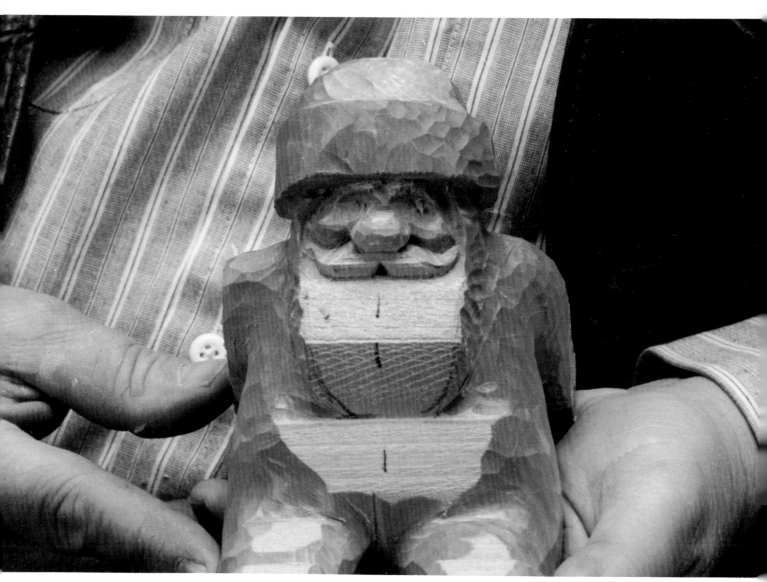

The result.

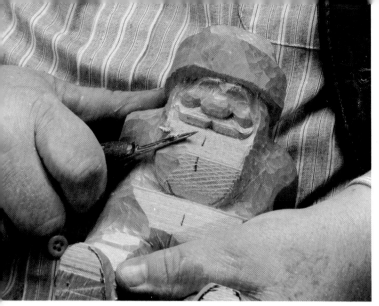

Round off the beard.

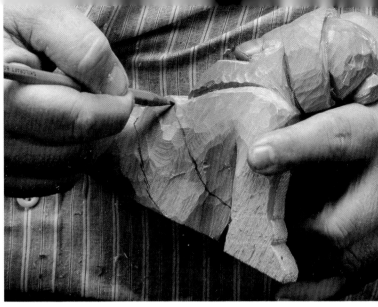

Draw in fur trim of the coat.

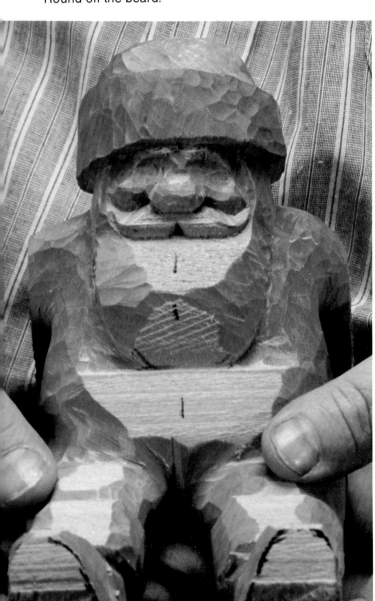

The beard blocked out.

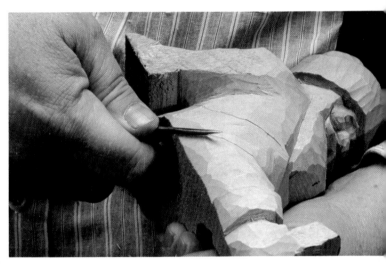

Cut a stop around the bottom of the trim...

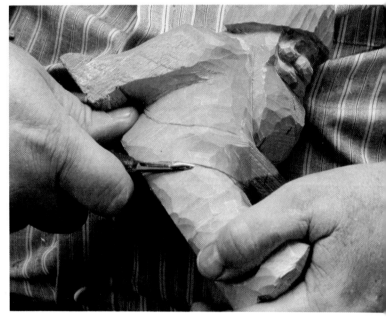

and cut back to it from the pants.

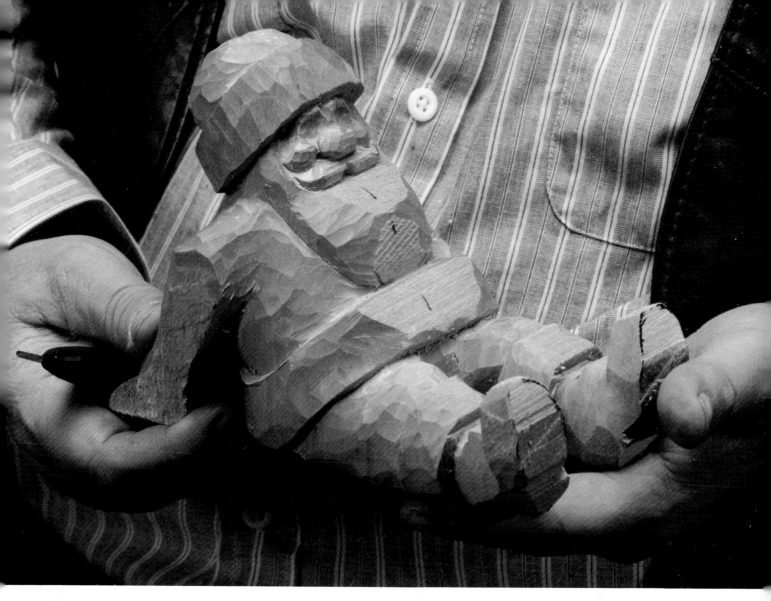

Do the same with the top, cutting down from the coat.

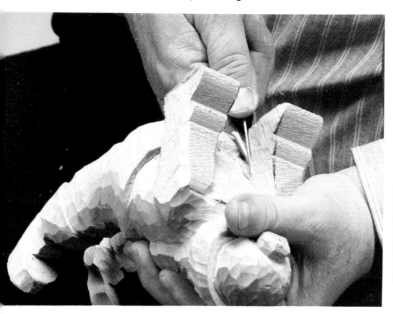

Round off the inside corner of the arms so you can continue with the coat trim.

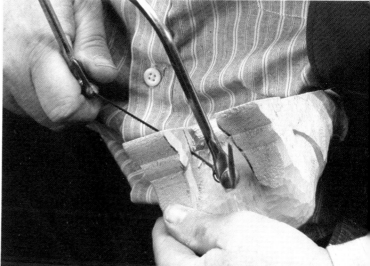

A coping saw does this job a whole lot easier. I like to put the coping saw blade in backwards so the cutting is done on the pulling stroke. This seems to give me much more control.

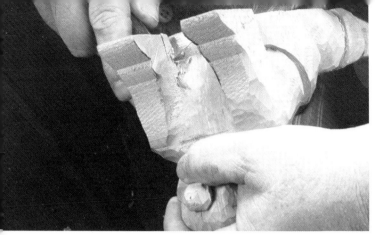

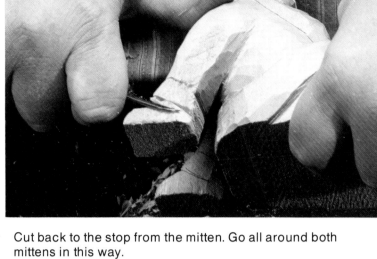

Use a long thin blade to clean up the cut. Places like this that are tight and go against the grain tend to be aggravating and require patience and perseverence.

Cut back to the stop from the mitten. Go all around both mittens in this way.

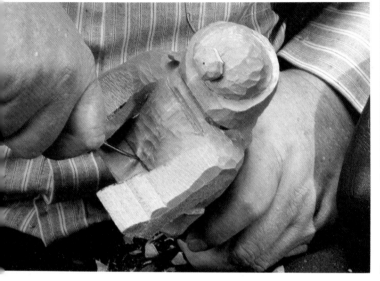

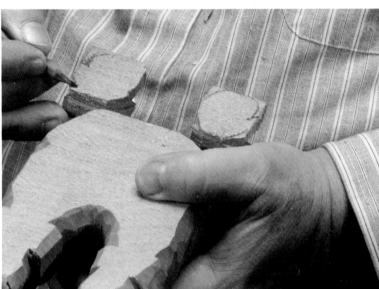

After you access to the back redraw the line of the trim, cut a stop, and cut back to it. You can use a knife or a straight chisel for this. Almost everything in carving can be done with either tool, but the right tool can make your work a whole lot easier.

Draw the shape of the mittens (thumbs out) on the bottom of the hands.

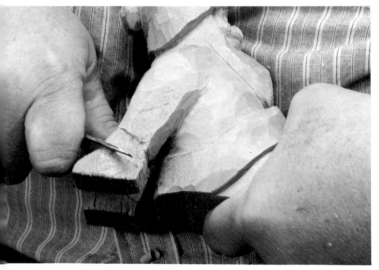

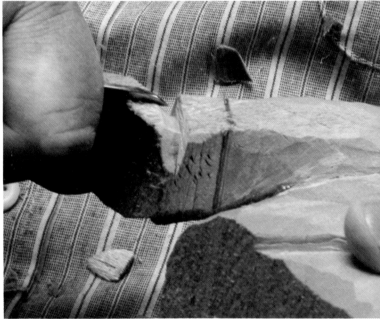

Mark the cuff of the sleeve and cut a stop around the mitten.

Trim the mitten to the shape...

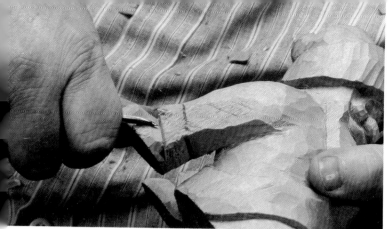

and cut in the thumb.

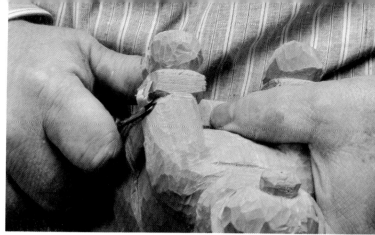

Shape the arm...

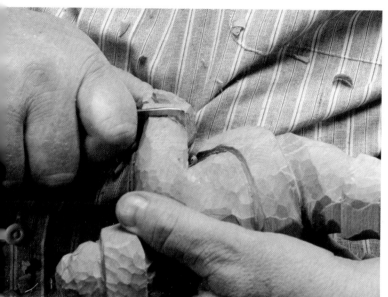

Cut a stop around the top of the fur trim of the sleeve...

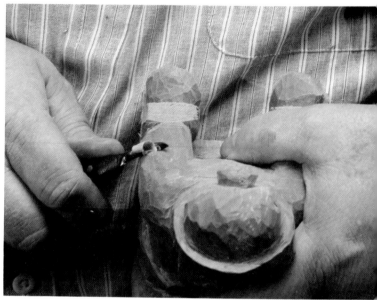

as you go.

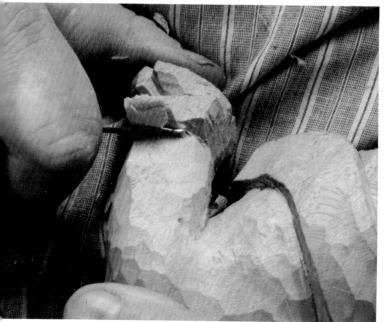

and cut back to it from the sleeve. Continue all around the arm.

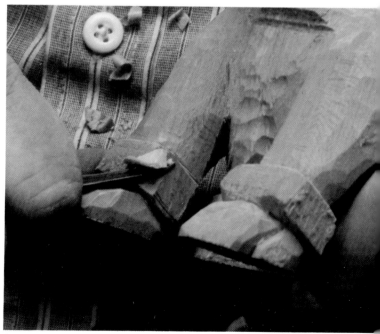

Knock the corners off the fur trim of the sleeve...

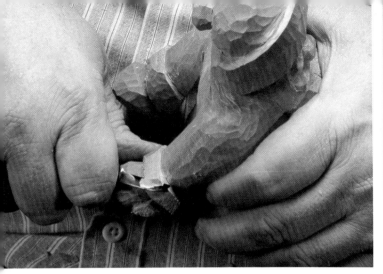

and round it off.

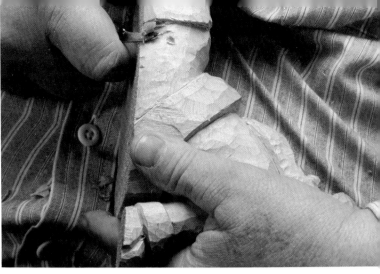

Carve a groove in the back of the leg...

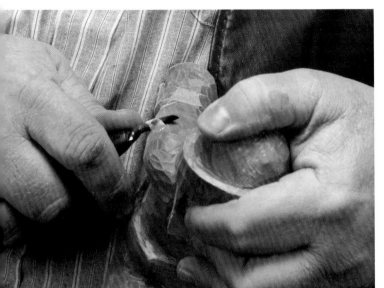

The arm looks a little beefy, so I'll thin it down. You should keep looking over your work as you go and make corrections as you see them.

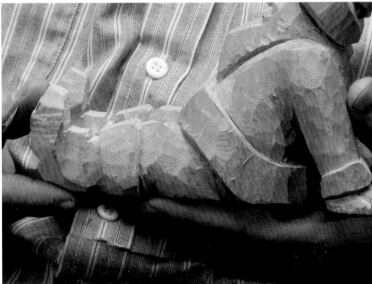

to give this impression of the bend in the back of the knee. Be sure to do the other side.

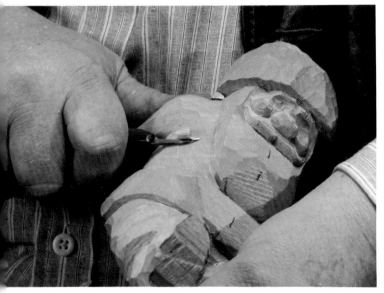

Continue refining.

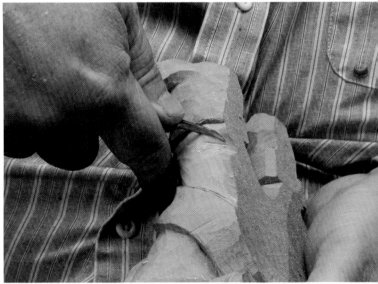

Cut some v-lines in the groove behind the leg to represent folds in the fabric.

28

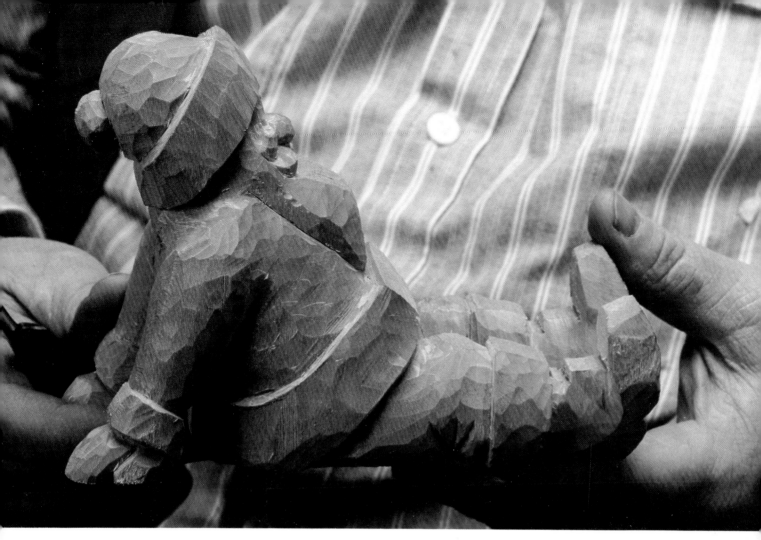

This is the result.

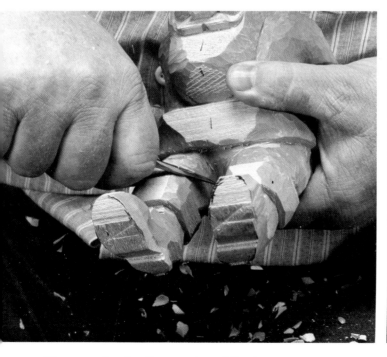

Shape and refine the carving of the legs.

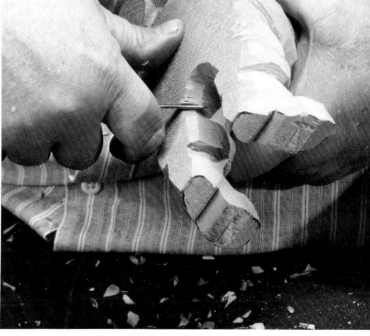

Cut similar v-line creases on the inside of the leg.

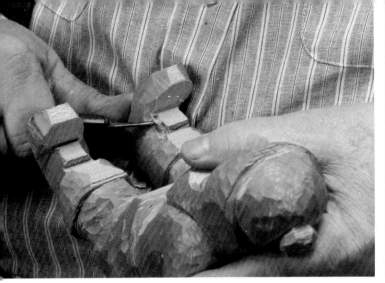

Square off the sides of the boot buckles. You may decide to make this a tassle, a rosette, or some other decorative attachment...or leave it off altogether.

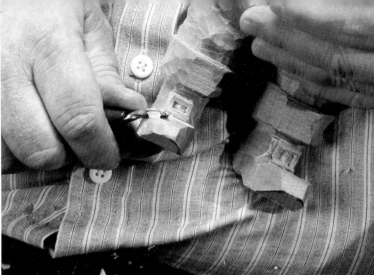

Begin finishing the boots by rounding the toes...

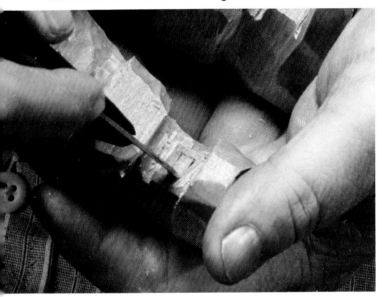

Cut stops around the inside of the buckle

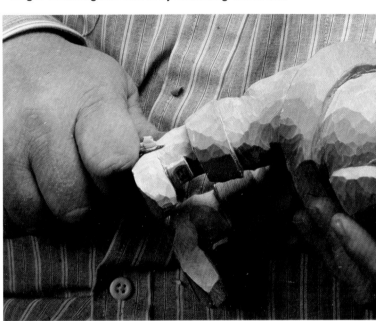

and shaping the sides.

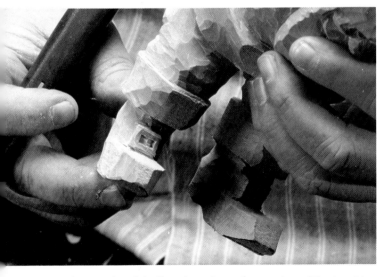

and carve back to the stops from the center of the buckle to give this look.

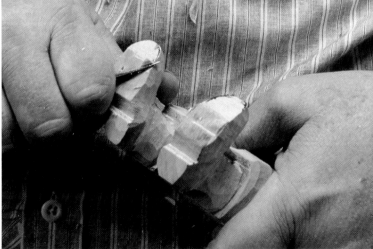

Clean up the soles of the feet, removing saw marks and pencil marks.

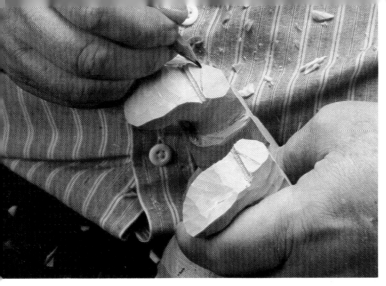

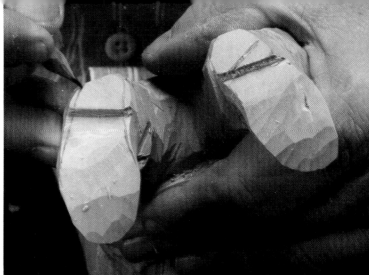

The heel line from the original blank is not the right line for the new direction of the boot, so we'll need to change it. Draw in the new line.

The heel looks too wide, so we'll narrow the foot to compensate.

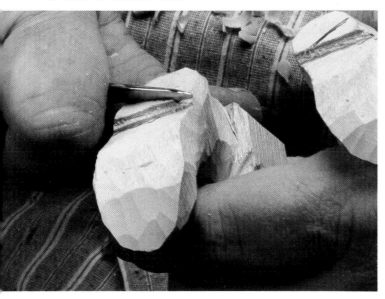

Cut a stop along the new mark...

Trim the sides back to the line, cutting out the line as you go. Do the same with the other foot.

and trim back into it.

Cut v-lines with your knife to represent creases in the leather boots. I usually make two in the front of the ankle and two in the back. I add one along the side to connect them.

Do the same thing on the inside of the ankle.

Back at the boot, we need to add a sole. There are two ways you can do it: with a veiner or with a knife. The veiner is faster if it works. I am doing it without a pencil mark, but you might wish to draw the sole in first.

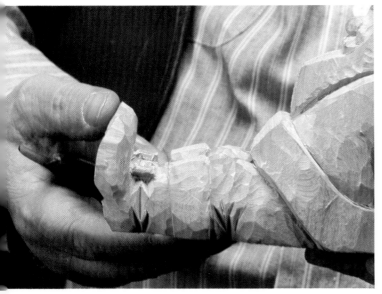

This is the look I like the boot creases to have.

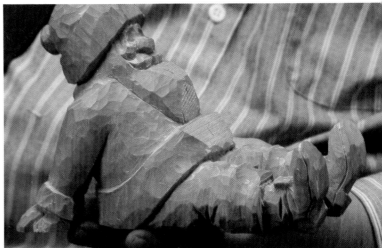

This pose gives a good view of the finished boots.

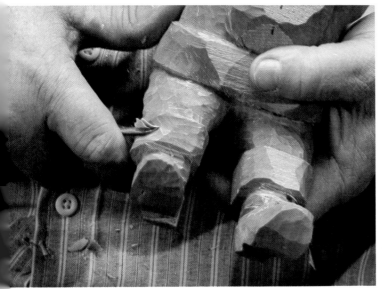

Shape the cuff of the boot. I make the cuff look cupped in, making it seem more like it is folded over.

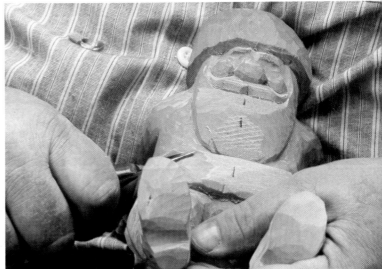

Smooth the lines on the fur trim of the coat. Don't round it too much yet, since you will be going over it with a gouge to get the furry look.

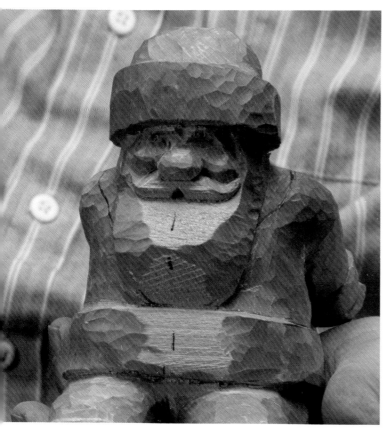

Draw in the collar line, front...

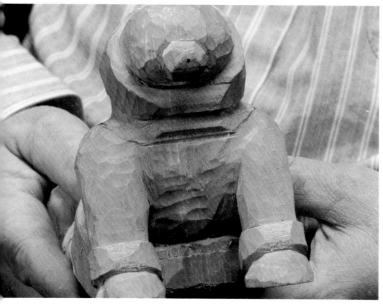

and back.

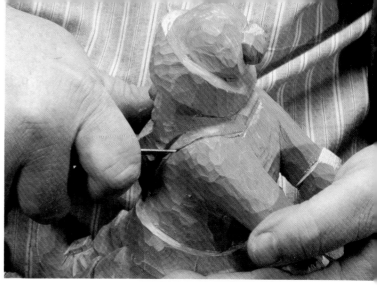

Cut a stop around the collar line

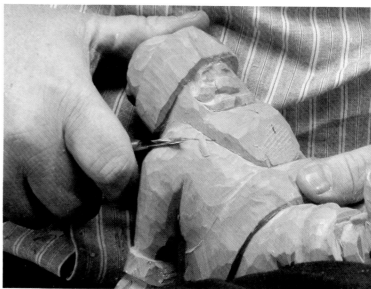

Come back to it from the coat.

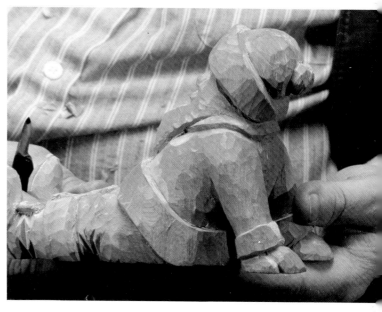

The collar defined.

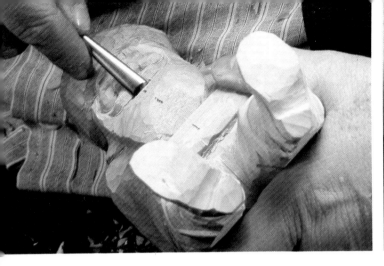

Now we turn to the face. To form the bottom lip go straight in with a gouge, cup side up, to form a stop.

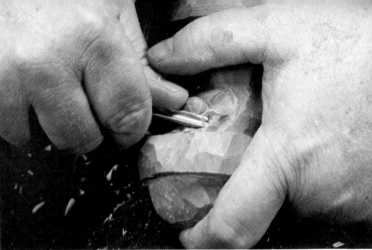

Use a gouge to straighten up the eye sockets, making them the same on both sides.

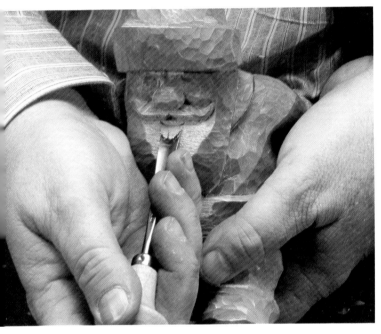

Come back to it from the beard, gently rocking the gouge back and forth.

Choose an eye punch that fits the socket and is proportional to the head.

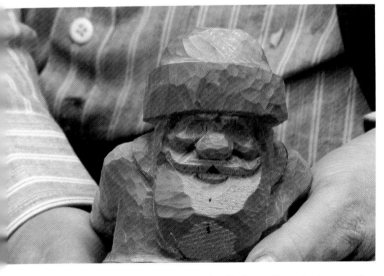

With those two cuts you basically form the whole mouth.

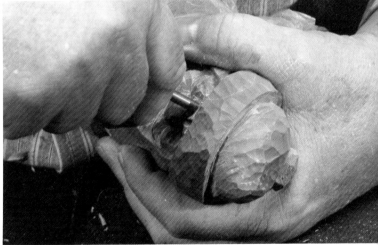

Doing the left eye first, push and rotate the eye punch to form the iris.

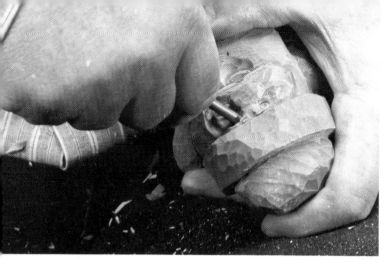

Line up the right eye and do the same thing. If you are right-handed, doing the eyes in this order will give you the best perspective on the work and help assure that the eyes are even and balanced. If you are left-handed, do the right eye first.

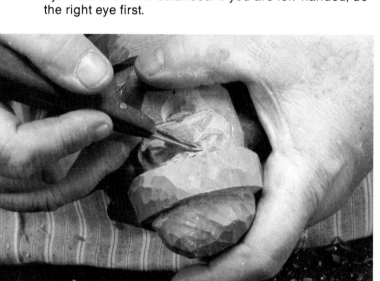

With your knife almost flat against the iris cut a line into the outside corner of the eye. This cut will follow the curve of the eyeball, and when the corner is popped out will make the eye seem bigger.

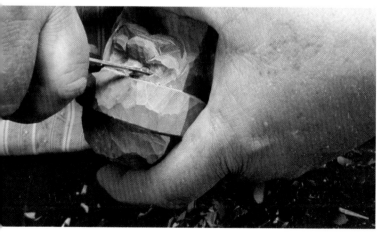

One angled cut to the corner above...

and one below should cause a triangular piece to pop out leaving a nicely shaped corner of the eye.

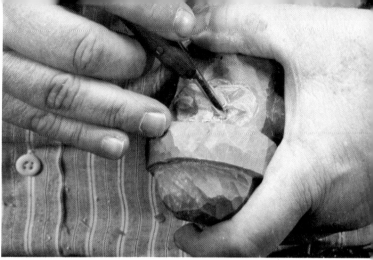

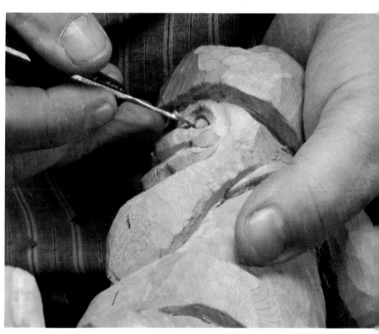

Do the same on the other eye. Then cut a smaller nitch in the inside corner of each eye using the same technique.

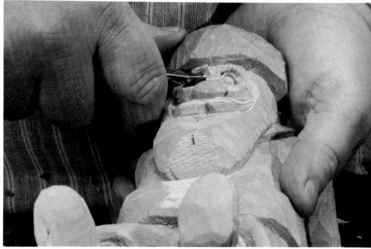

To form the eyelid, start at the inside corner of the eyelid and make a short cut parallel to the curve of the eye.

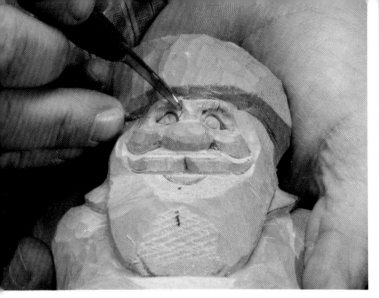

Cut another small cut parallel to the curve of the nose.

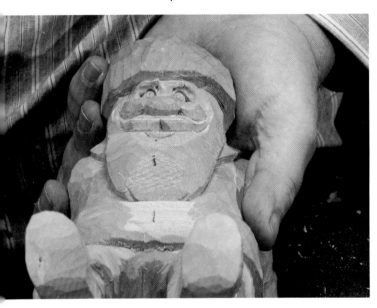

Lift out the wood between to get this small triangle which gives the eyelid its shape.

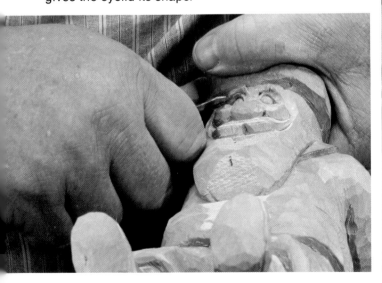

Now, starting at the inside corner of the triangle, cut the first line of a v-cut following the curve of the eyelid.

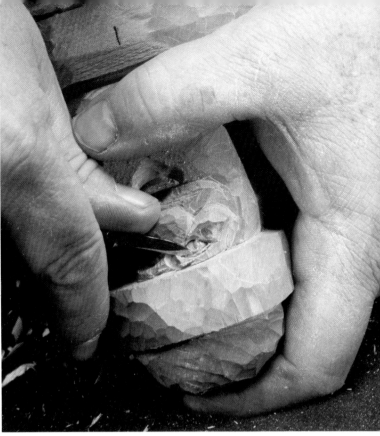

Come back with the second cut and pop out the wedge between.

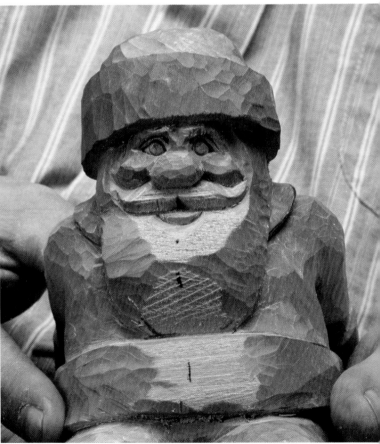

Here are the eyes to this point. In a later step we will add the pupil to the center of the iris.

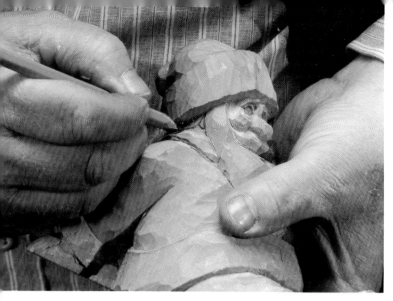

Draw in the beard line, the hair line, and the lobe of the ear on both sides of the head.

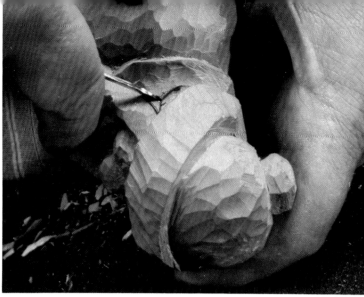

and the ear line.

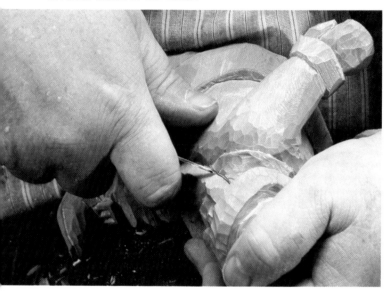

Cut a stop on the beard line...

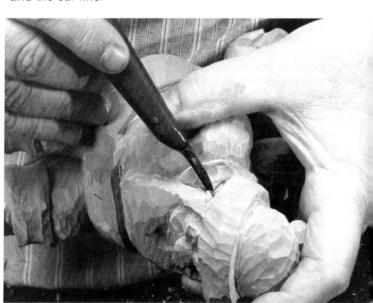

Cutting at an angle, go in just above the earlobe stop, and cut into the triangle formed by the hair and beard lines popping out the small triangle.

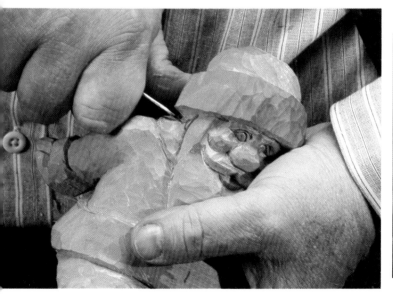

the hairline...

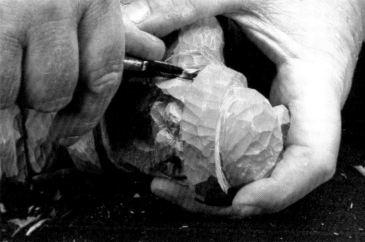

Cutting up from the collar trim back to the earlobe stop. This will leave just a little rim of earlobe.

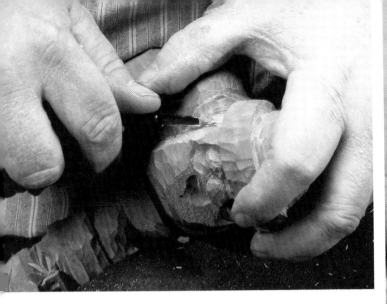

Finally, cut in from the collar to the beard line stop.

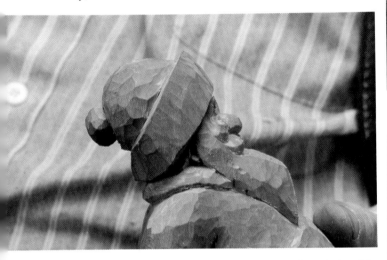

The earlobe is formed, and the side of the head should look something like this.

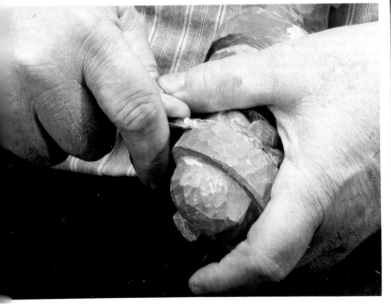

Using a small half-round gouge, begin to put details in the fur of the hat. Go across the grain so it will be in contrast to the flow of the beard.

Continue all the way around.

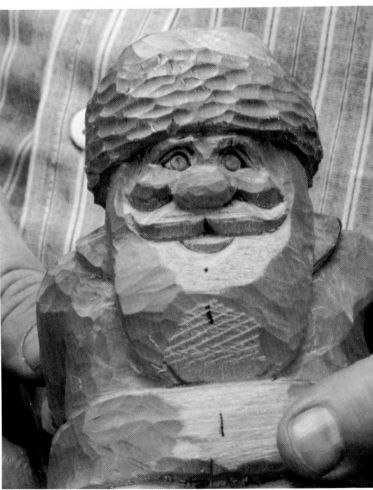

The finished fur.

Continue the process on the ball at the back of the head.

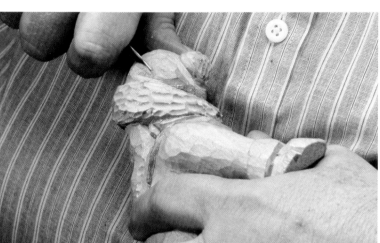

Put three folds in the side of the hat, almost like you did on the knee.

The finished hat looks like this.

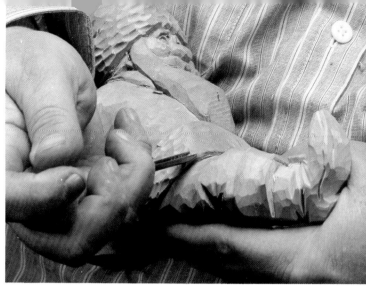

Using the gouge, continue the fur effect around the cuff of the coat, the bottom of the coat...

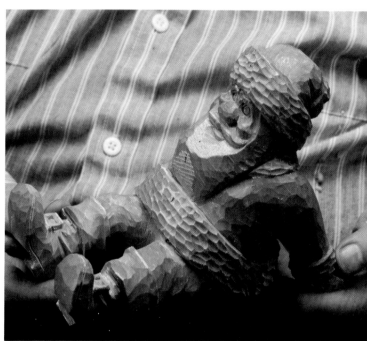

and the collar. This finishes the fur effect.

For the beard I use a small veiner.

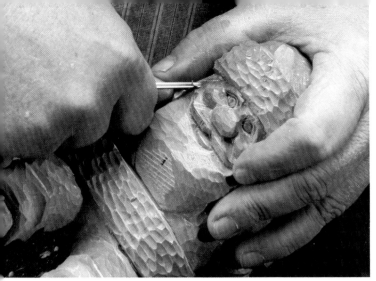

Start on the sideburns and move down into the beard.

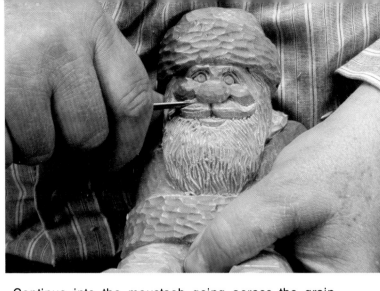

Continue into the moustach going across the grain. When using a veiner across the grain it has to be sharp or it will tear the grain and look bad.

Move around to maintain balance and form.

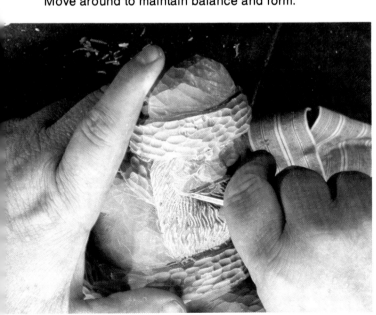

Your goal is cover the beard area in a flowing way.

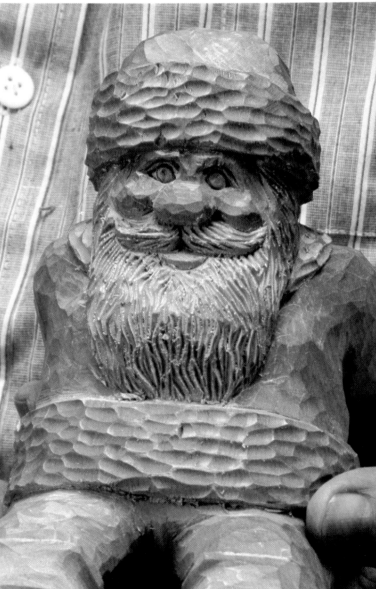

The facial hair.

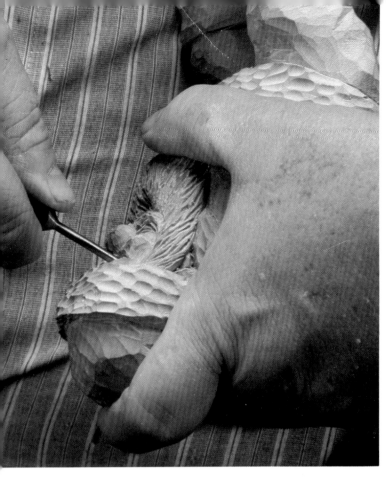

We now need to add a pupil to the eye. Use a smaller eye punch and center it in the iris. Push and turn.

I use tracing wheels to create stitches in clothing. They come in a variety of sizes. I will use a small wheel with few teeth.

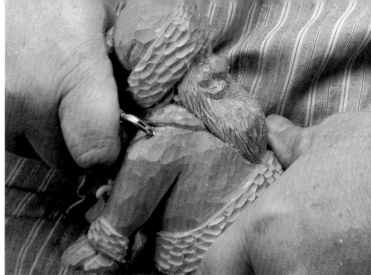

Run the wheel along the line where the sleeve meets the coat.

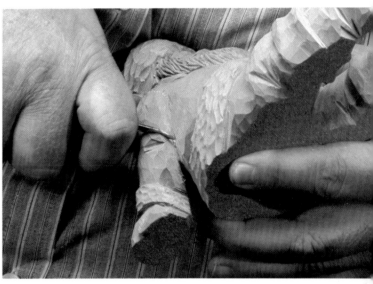

Put two or three v-cuts in the elbow to give the look of fabric.

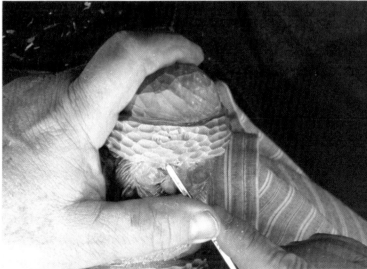

I missed putting hairlines in the eyebrows, so I'll go back and do it now with the veiner.

41

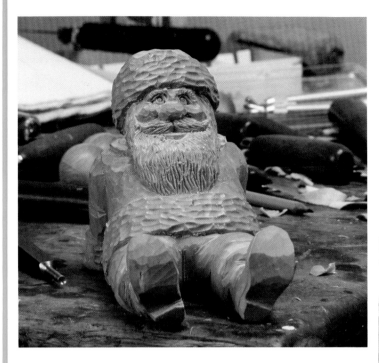

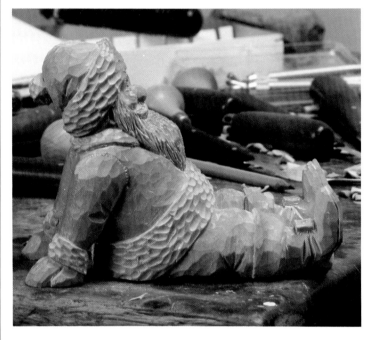

Ready to paint.

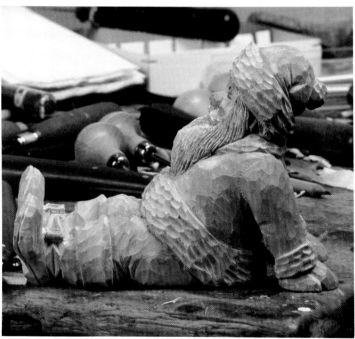

Painting the Traditional Santa

For wood carving I use Winsor and Newton Alkyd tube paints. These are thinned with turpentine to a consistancy that works with the carving. I mix my paints in glass juice bottles, putting a bit of paint and adding turpentine. I don't use exact measurements. Instead I use trial and error, adding a bit of paint or a bit of turpentine until I get the thickness I want.

What I look for is a watery mixture, almost like a wash. In this way the turpentine will carry the pigment into the wood, giving the stained look I like. It has always been my theory that if you are going to cover the wood, why use wood in the first place. It should be noted that with white the concentration of pigment needs to be a little stronger.

The juice bottles are handy for holding your paints. They are reclosable, easy to shake, and have the added advantage of leaving a concentrated amount of color on the inside of the lid and the sides of the bottle which can be used when more intense color is needed.

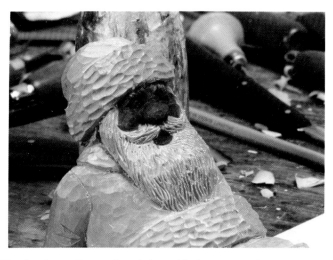

Do the face, lip, and earlobe with the burnt sienna.

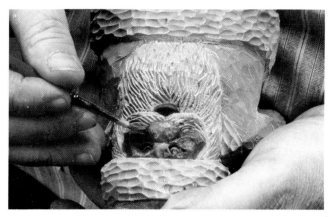

Go over the burnt sienna with the flesh/raw sienna mixture to bring out highlights.

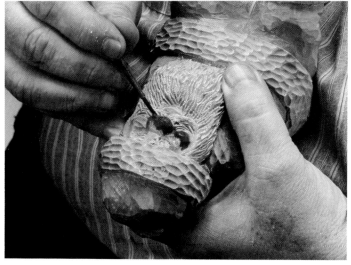

For the skin of our black Santa we will use a burnt sienna as the base color. If this were to be a white Santa we would use a tube flesh tone mixed with a touch of the raw sienna to make it less pink. After this undercoat and the wash that follows, the painting technique is the same for black or white Santas.

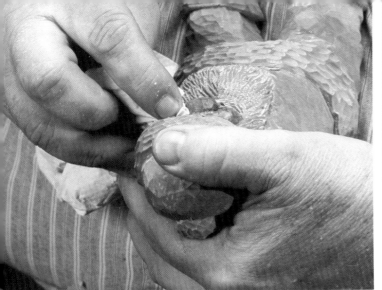
Wipe off the excess.

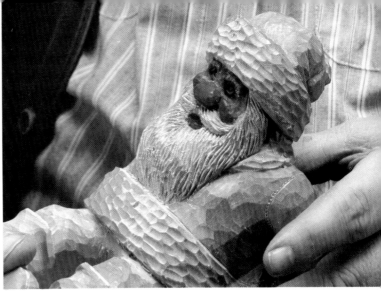
The painting thus far.

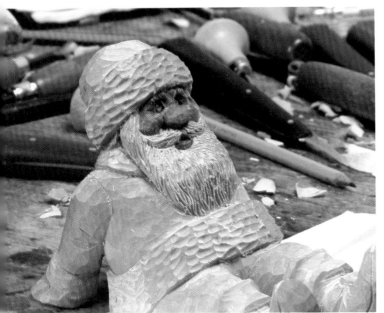
This second color keeps Santa from having a flat look.

Next we apply the white. Begin with the ball of the cap.

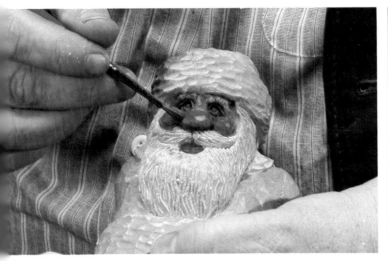
Apply red to the lips, cheeks, and nose, with a little on the ear lobes. Dry brush it to blend.

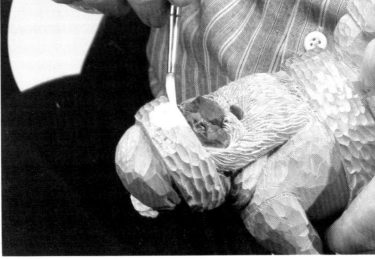
Continue with the fur trim of the cap...

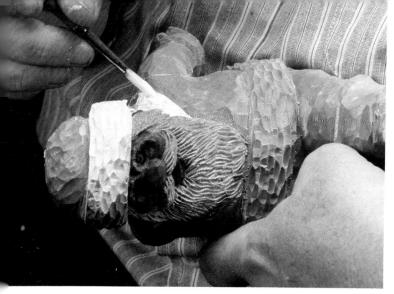

and the collar.

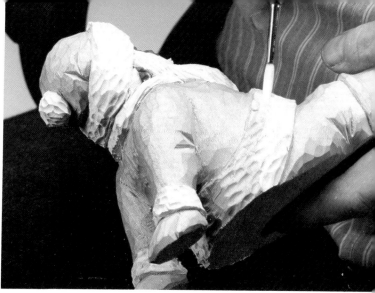

and the fur trim.

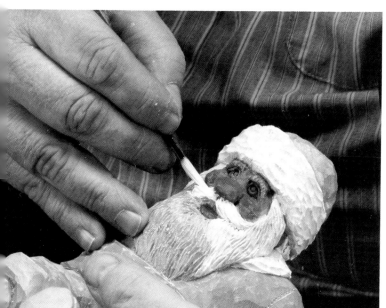

The beard and moustache are next...

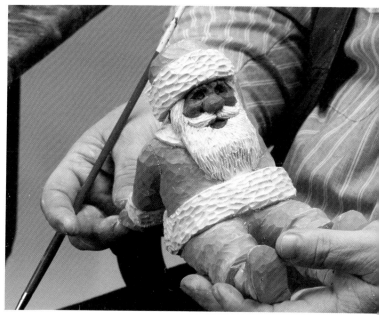

Ready for red.

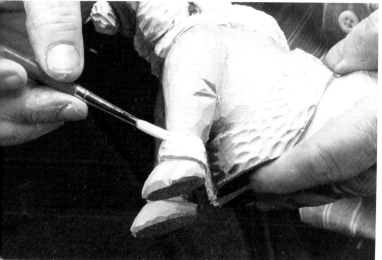

followed by the cuff...

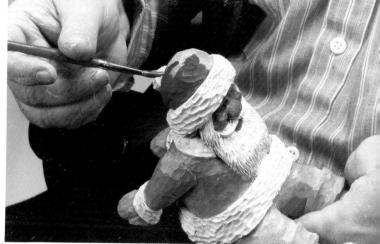

Alizarin Crimson mixed in turpentine makes a good Santa Claus red. Begin on the hat.

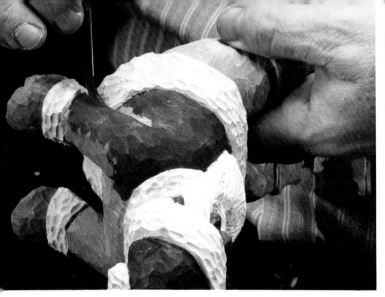

Continue with the coat...

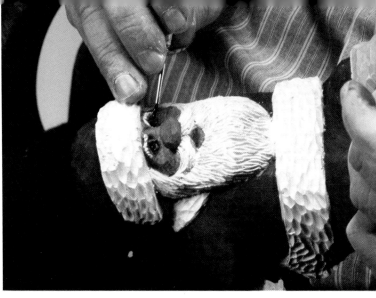

and black in the pupil.

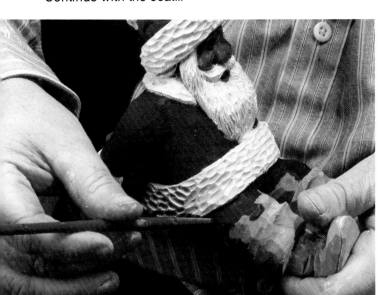

and the pants.

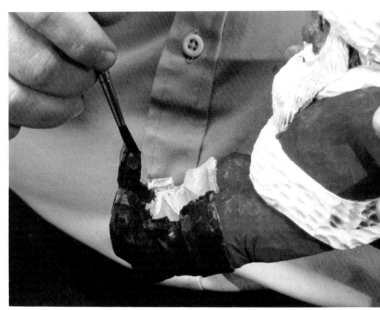

Paint the boots black.

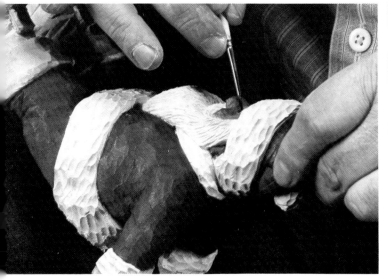

Apply burnt umber to the iris...

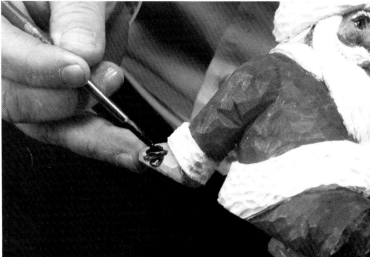

You can use various colors on the gloves including dark green or brown. In this one I'm going to use black.

46

The painted Santa.

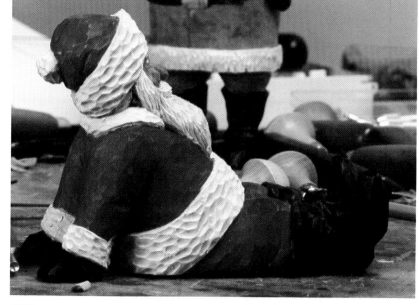

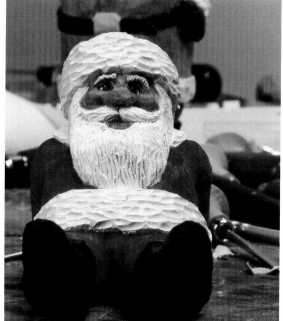

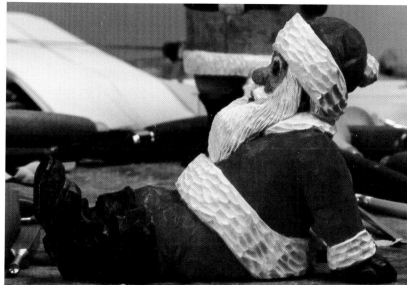

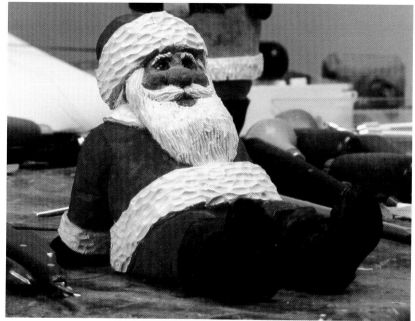

Carving the Pencil

Pedigree makes a Husky™ plastic pencil that is a good basis for the pencil Santa Claus. I begin by carving the paint off down the name side.

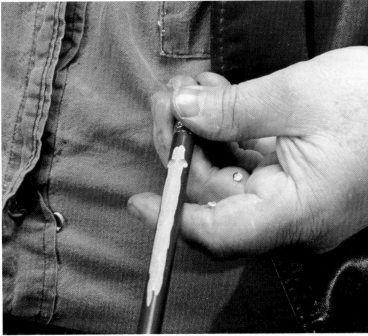

Do both sides for this effect.

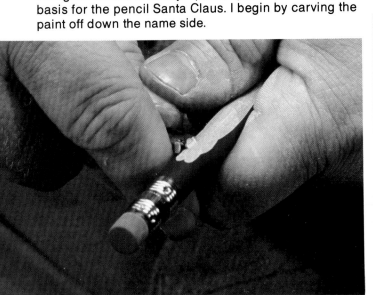

Gouge out the eye sockets first.

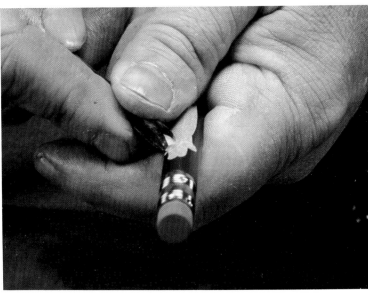

Gouge up each side of the nose to the eye.

With a knife cut a stop across the bottom of the nose.

Cut back to it from the moustache.

Cut back to it from the moustache.

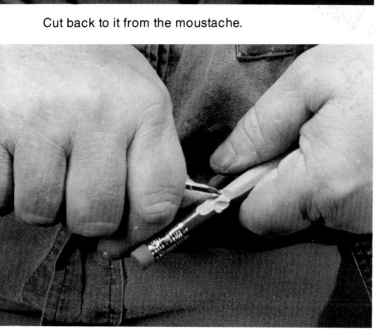

Nip off the side of the nostril with a stop cut...

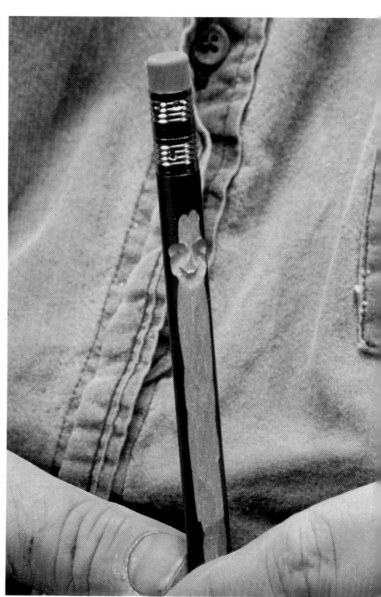

Progress so far.

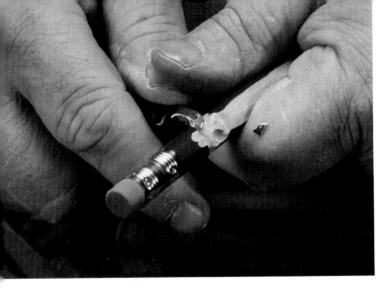

Score the area below where the hat will go with the knife.

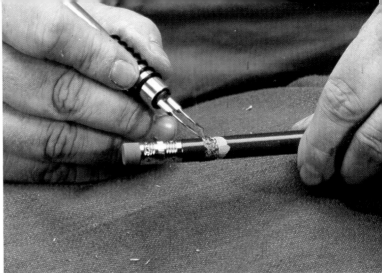

Continue around the hat.

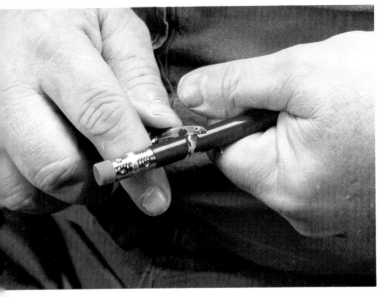

Continue it around the back.

Burn the cheek line above the moustache.

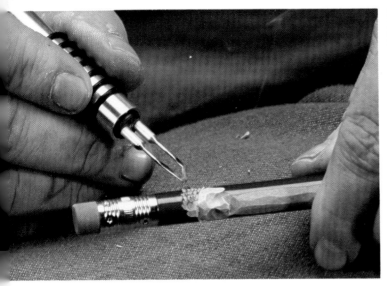

With a wood burner make the fur hat band around the hat, using short, sideways strokes, touching the pencil lightly with the burner.

Burn in the top of the moustache...

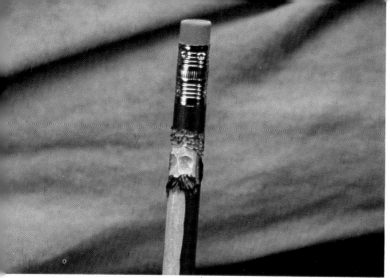

and the hairline in front of the ear.

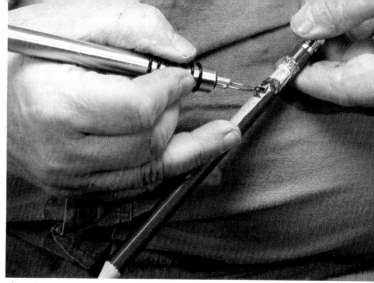

Use the point of the burner to form the area for the mouth. Because the pencil is plastic, this area just melts away.

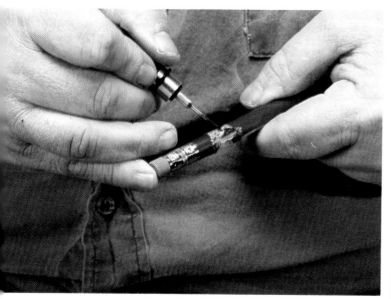

Burn in the collar in back of the head...

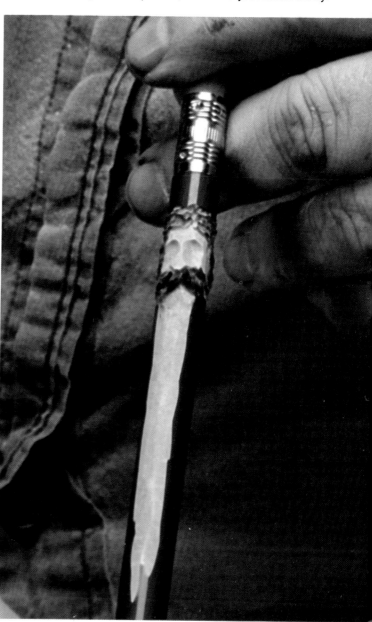

The pencil so far.

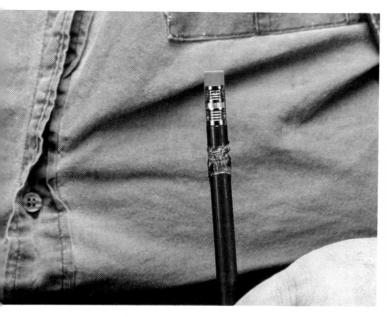

and burn the hair between the cap and the collar.

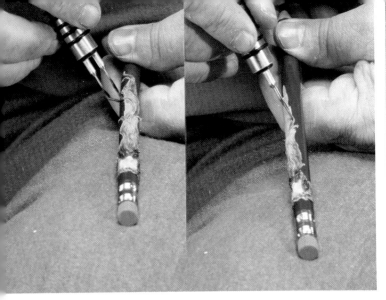

Burn the beard down the pencil, in long flowing strands.

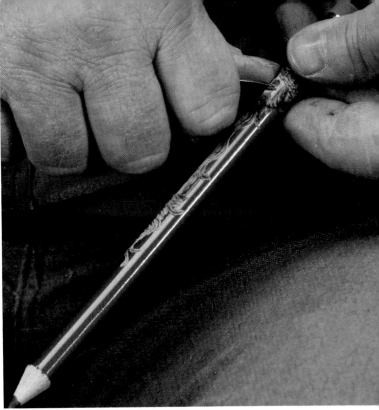

Cut a little notch out of the corner of the eye.

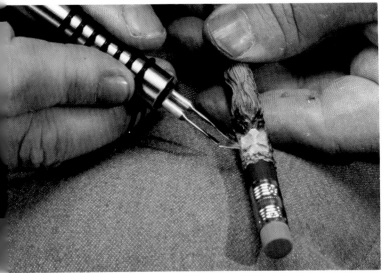

Burn in the eyebrows.

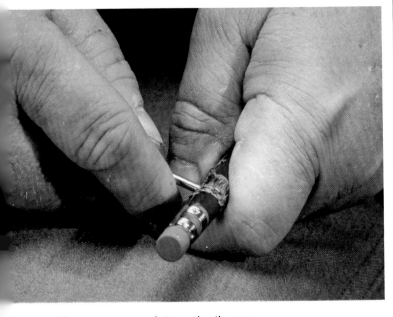

Use an eye punch to make the eye.

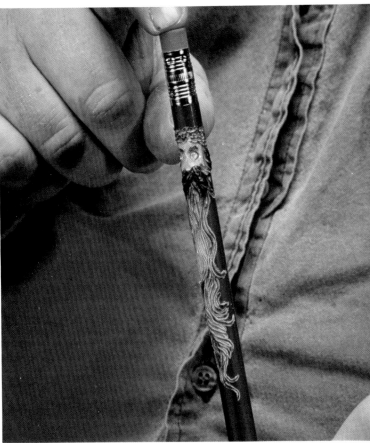

The finished Santa pencil. It should be painted with acrylics for best results. An eyescrew in the eraser makes it into a nice tree ornament or pendant for a necklace, or it can be used as a pencil.

Gallery of Carved Santas

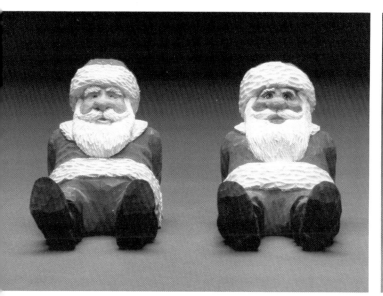

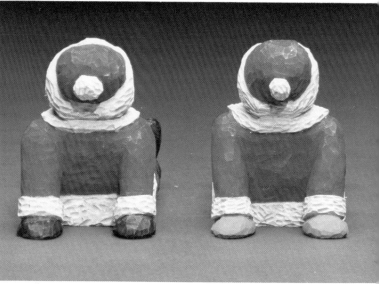

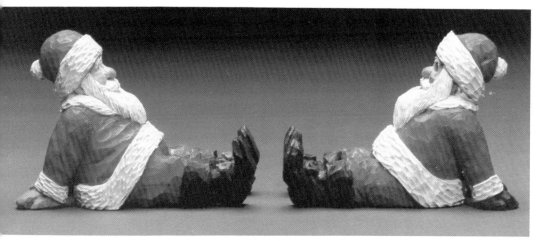

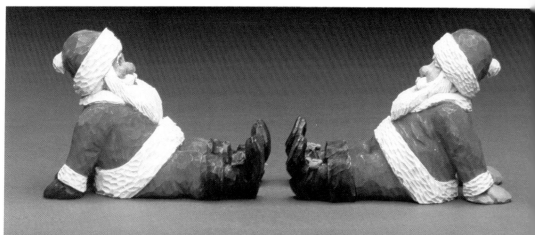

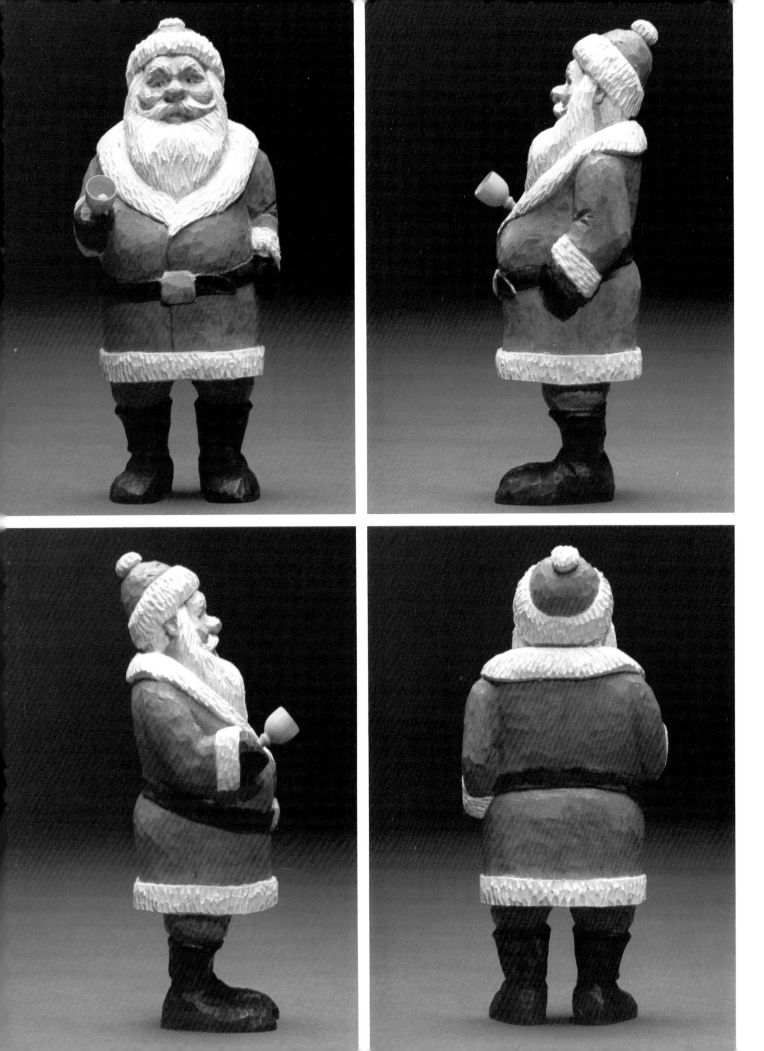

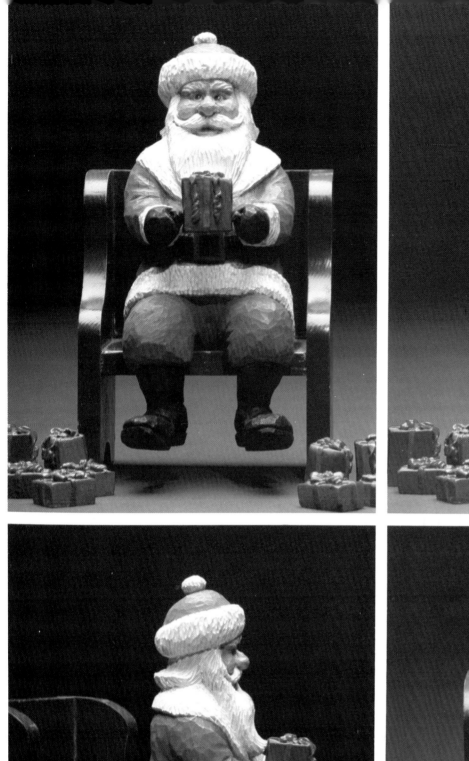
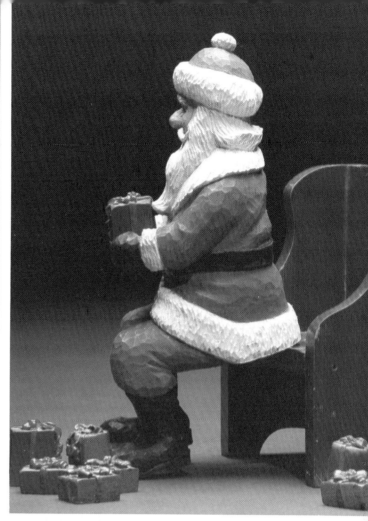
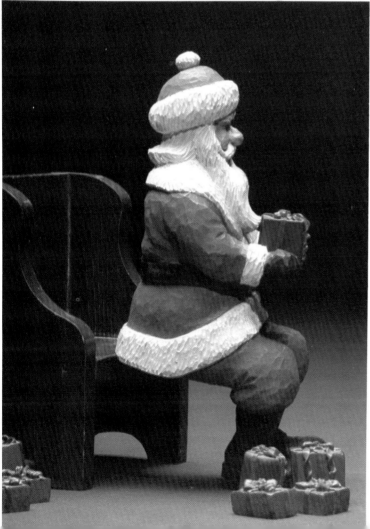
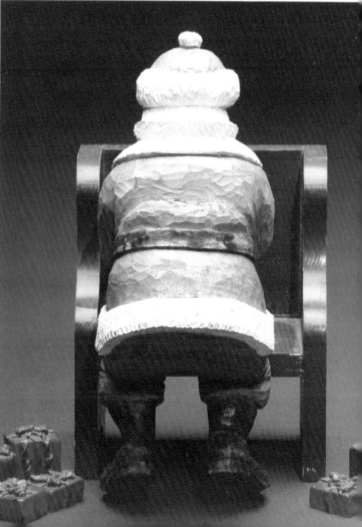

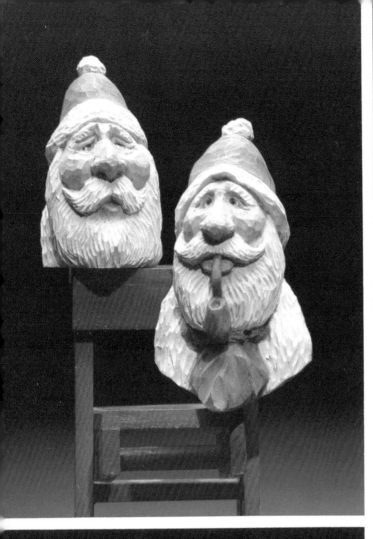
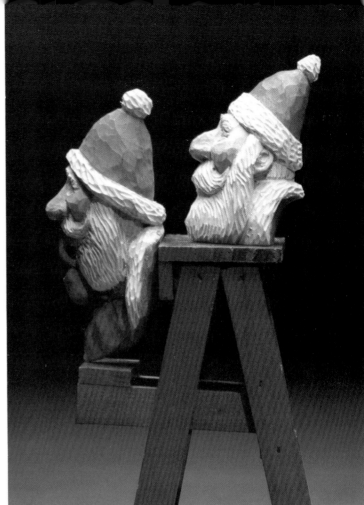
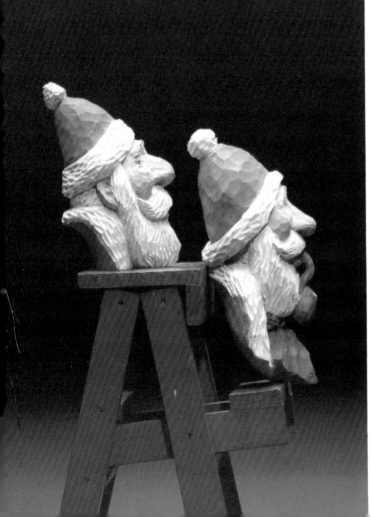
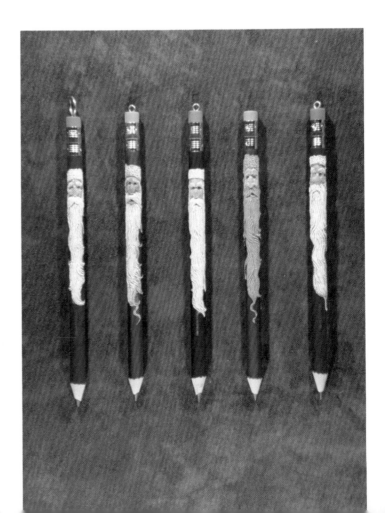

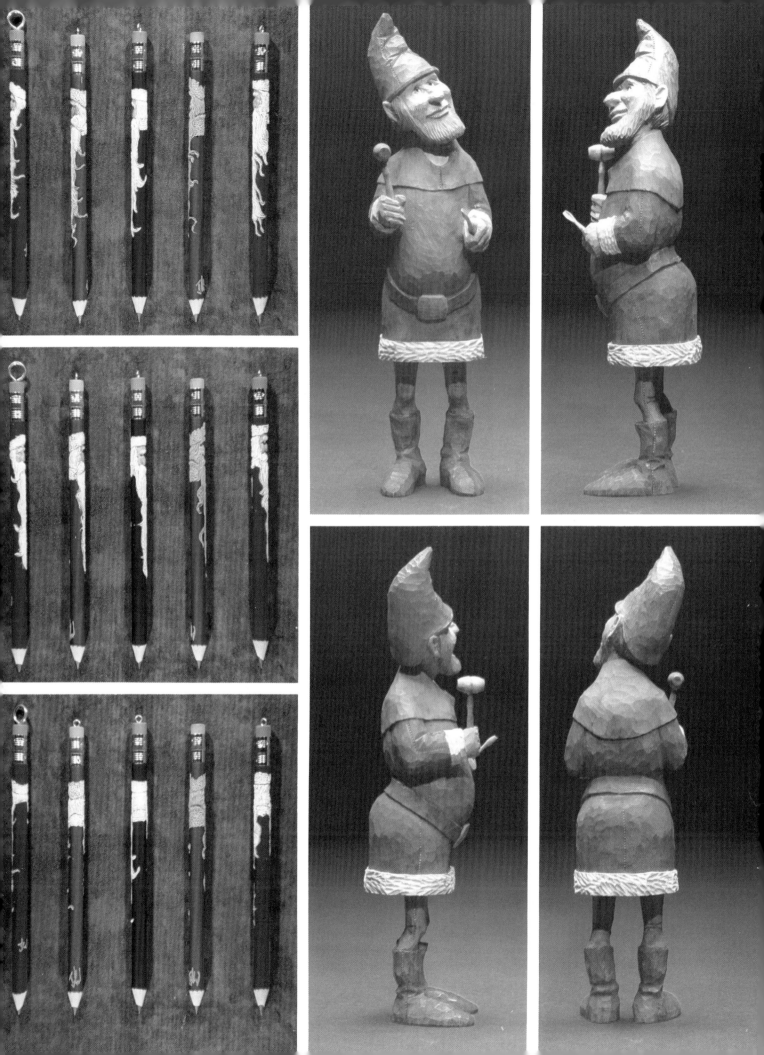

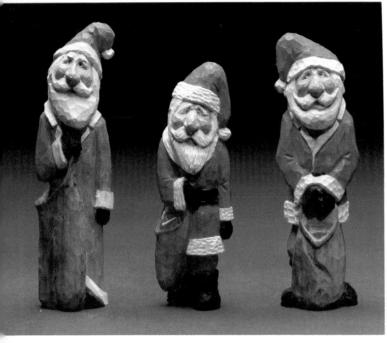

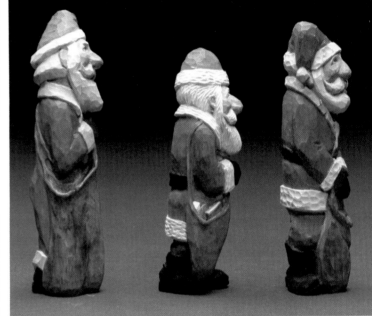

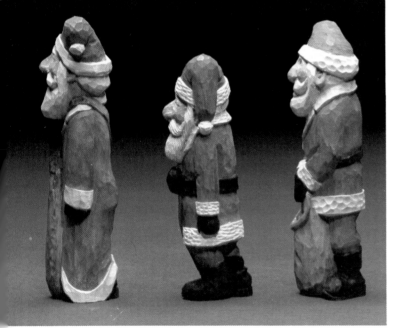

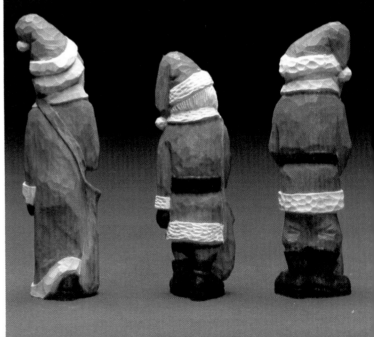

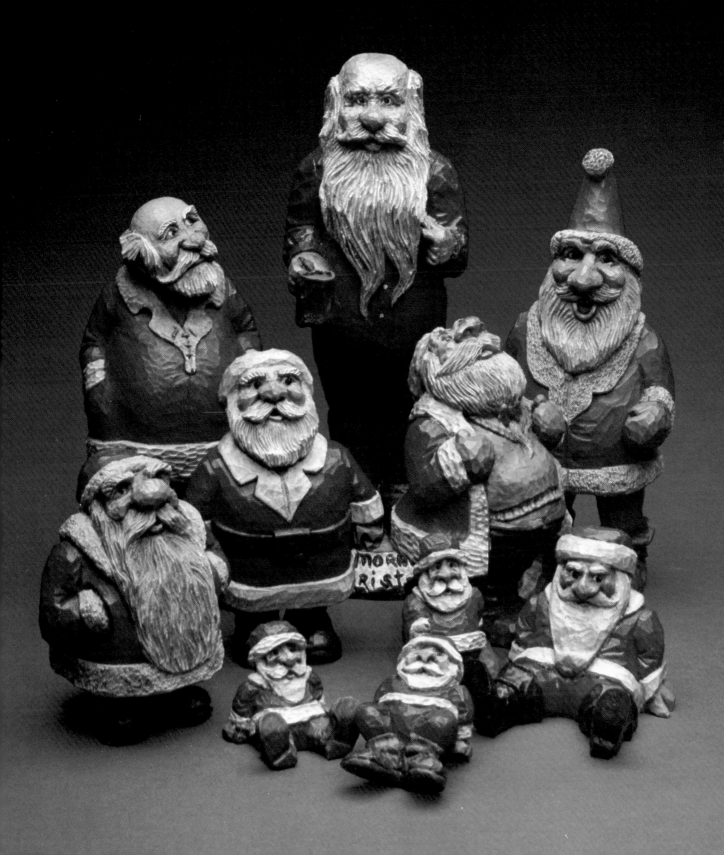

"Study Models"

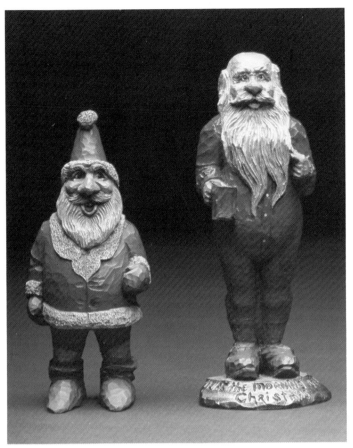

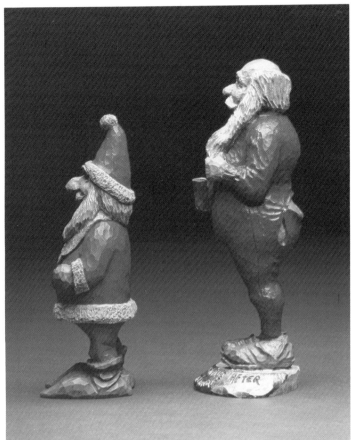

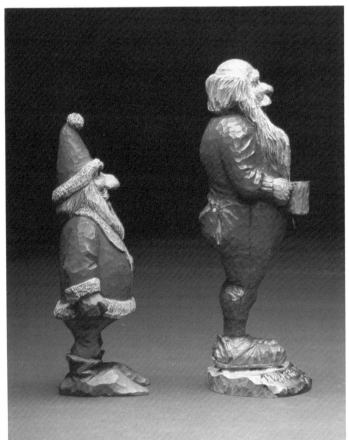

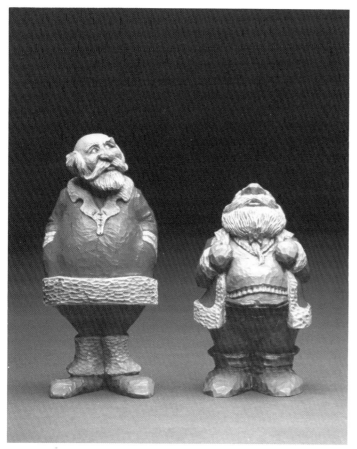
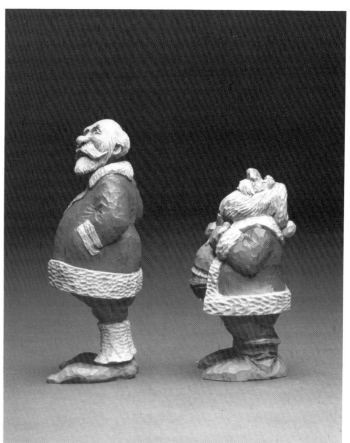
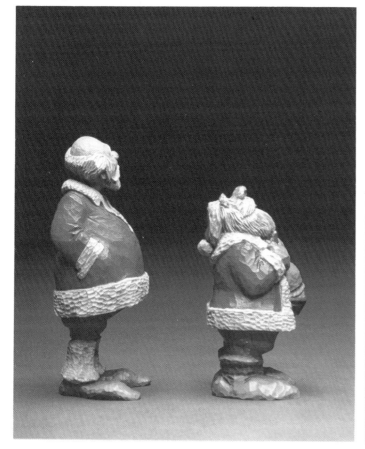
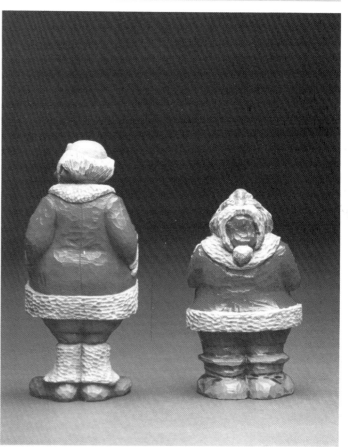

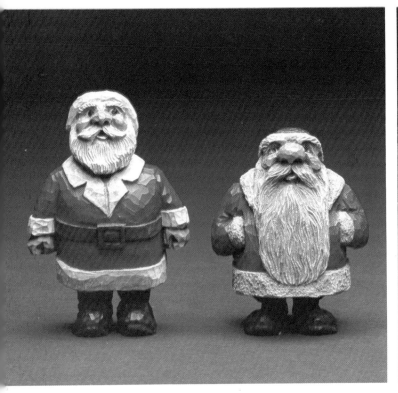

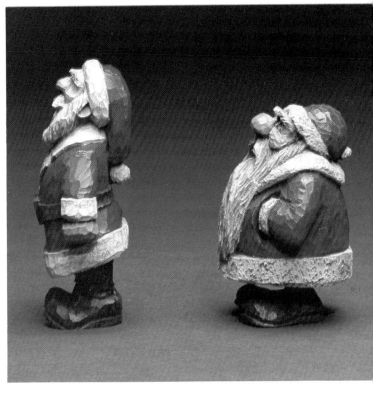

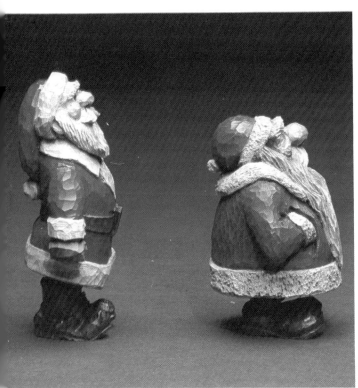

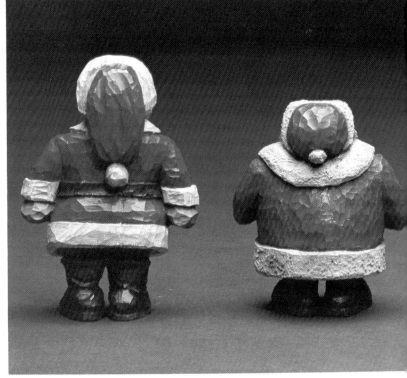

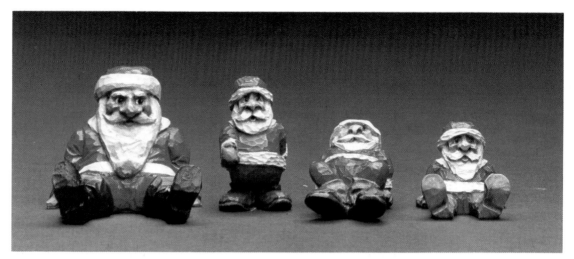

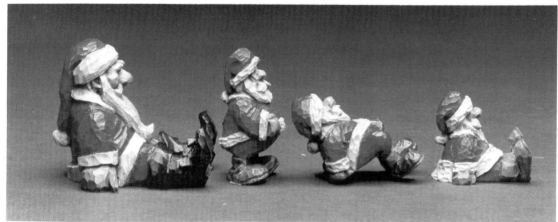

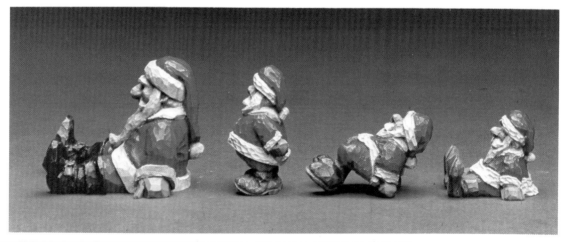

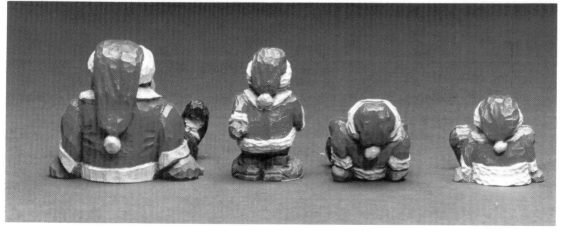

Carving Bears and Bunnies

Tom Wolfe

Text by Douglas Congdon-Martin

Country Carving

By Tom Wolfe

THE GOLFERS

Carving with Tom Wolfe

Text written with Douglas Congdon-Martin

Pig Pickin'

Country Carving

Santa and His Friends:
Carving with Tom Wolfe

Text by Douglas Congdon-Martin

Country Dollmaking

by Nancy and Tom Wolfe

TOM WOLFE GOES TO THE DOGS:

Carving Dogs

Text written with Douglas Congdon-Martin

CARVING OUT THE WILD WEST WITH TOM WOLFE

The Saloon

Text written with Douglas Congdon-Martin

Country Flat Carving with Tom Wolfe

Text by Douglas Congdon-Martin